To: Gil and Margaret

Wishing you joy
this Holiday Season

Ed, Leah and your
USC Andrus Center family

December 2001

from Ed and Leah

Gilded Vessel

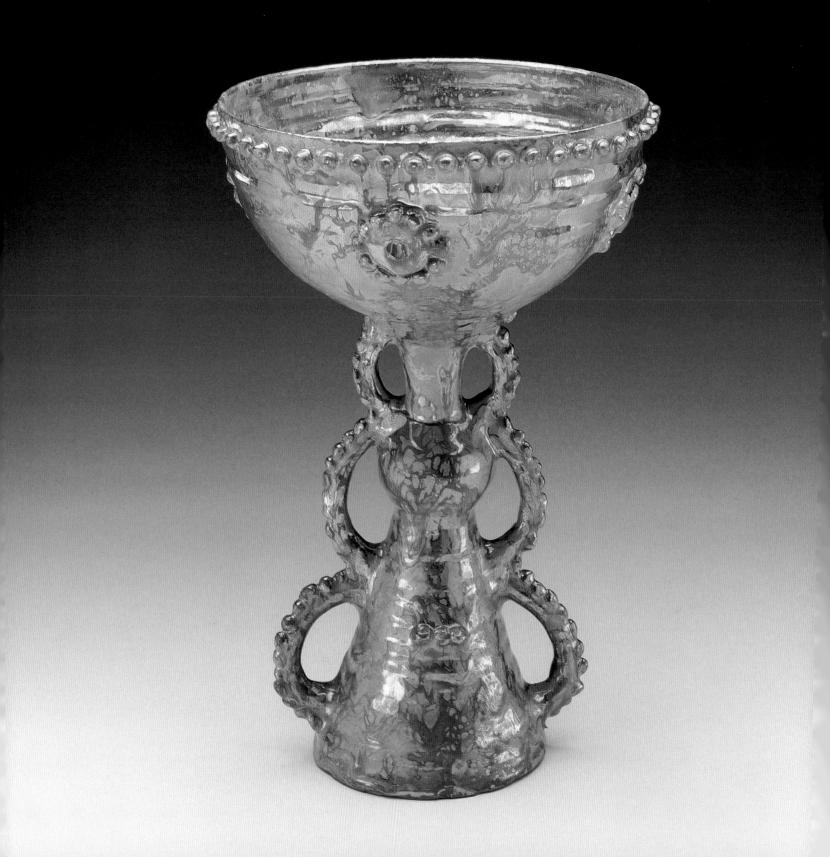

THE LUSTROUS ART AND LIFE OF

Beatrice Wood

Gilded Vessel

GARTH CLARK

GUILD PUBLISHING ✻ MADISON, WISCONSIN

Distributed by North Light Books, Cincinnati, Ohio

GILDED VESSEL
The Lustrous Art and Life of Beatrice Wood
Garth Clark

Published by GUILD Publishing
931 E. Main Street, Madison, Wisconsin 53703
TEL 608-257-2590 · FAX 608-257-2690

COVER AND INTERIOR DESIGN: Lindgren/Fuller Design
CHIEF EDITORIAL OFFICER: Katie Kazan

Distributed by North Light Books
An imprint of F&W Publications, Inc.
1507 Dana Avenue, Cincinnati, OH 45207
TEL 800-289-0963

ISBN: 1-893164-13-6

Printed in Singapore

Copyright © 2001 Garth Clark

JACKET FRONT: *Close-up at 100* © 1993 Marlene Wallace; *Luster Urn, 1987, 14³/₄" h* (see page 68);
JACKET BACK: *Angel* © 1988 Marlene Wallace; PAGE 2: *Six Handled Beaded Chalice, 1991, 12" h;*
PAGE 3: *Wood at her 105th birthday party;* PAGE 5: *Wood and Anaïs Nin, Ojai, 1965;*
PAGE 6: *Detail of vessel on page 67, inset: Wood at Hollywood High School, c. 1933*

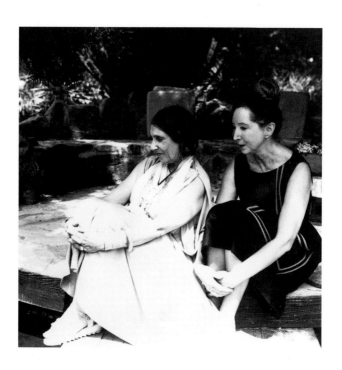

Beatrice Wood combines her colors like a painter, makes
them vibrate like a musician. They have strength even
while iridescent and transparent. They have the rhythm
and luster both of jewels and human eyes. Water poured
from one of her jars will taste like wine.

ANAÏS NIN

CONTENTS

•—•

The Art of Beatrice Wood

•—•

The Life of Beatrice Wood

•—•

ACKNOWLEDGMENTS

This is not a biography, though the format is loosely biographical. Nor is it meant to be a work of academic scholarship, yet I believe I have respected scholarly integrity in assembling the facts. It is partly a memoir of more than twenty years of friendship with a shimmering spirit whose life and art touched and changed my life and that of thousands of others who came to know and love her work. It is also a salute to the career of a ceramist who, though she took up this art at the age of forty, managed to work behind her potter's wheel for nearly sixty-five years until her death in 1998 at age 105. This is written with gratitude to Beatrice, who encouraged me to document her art rather than her life. I have chosen to combine both, as they are too closely laminated to peel apart, but the primary focus is on her luster ceramics: hence the book begins with photographs and not text.

I am indebted to many friends and colleagues who have helped in this endeavor: David VanGilder, Nancy Martinez, R. P. Singh, and, above all, to that dedicated and remorseless scholar Francis M. Naumann, without whose careful research we would not have had so clear a perspective of Wood's childhood and her early years within the Dada movement. My thanks above all to my partner, Mark Del Vecchio, who was my companion throughout my relationship with Beatrice and, as her dealer and friend, one of her greatest champions. Frank Lloyd, Patti Marcus, Greg Kuharic of Sotheby's, Gretchen Adkins, Osvaldo Da Silva, and Timothy Lomas gave their valued support, assistance, and encouragement to this project. Radha Sloss and Martin Gewirtz from the Beatrice Wood Trust have been invaluable in helping me get this book to press. Toni Sikes responded to the challenge of publishing this book with warmth and enthusiasm, and the text has benefited remarkably from my editor Katie Kazan's deft but light touch. Thanks, too, to the skill of gifted photographers Tony Cunha, John White, Marlene Wallace, and others who captured reflections of the elusive light that is Beatrice Wood's art. Working with Laura Lindgren and Celia Fuller could not have been a more satisfying experience, and in the book's design they have captured the romance of Beatrice's life and the glamour of her art to perfection. Lastly, this book is dedicated to my courageous friend and for many years a valued colleague, Wayne Kuwada, who pushed me to complete the book and whom Beatrice so loved.

—Garth Clark
New York, 2001

OPPOSITE
Detail of plate on page 24.

PAGE 11
Wood in her studio in Ojai, 1988.

August 5, 1996

Dear Garth:

I am impatient to read your manuscript! Not to see what
a fine writer you are, but to read how you seem to have
created me into some kind of ravishing creature that I
wish I could project to the handsome young men who
walk into my exhibition room!

Please hurry up and finish what you are working on!
Without any question, nothing would please me more
than to have your book dedicated to Wayne. This is
confidential between you and me, but I think Wayne is an
angel on wings!

Finally with the hope it will encourage you to visit Ojai, I
have a kiln started today. You know these last months it
has been almost impossible for me to honor my
workroom with my presence. The best I can do is an
hour and a half at a time. This is very hard for me to
endure because I have so many ideas fighting in my mind
to burst out into activity.

Know that there is a sandwich and chocolate eclair
waiting for you. In this hot weather, don't wait too long
to enjoy them!

Hugs, hugs, just hugs,

Beatrice

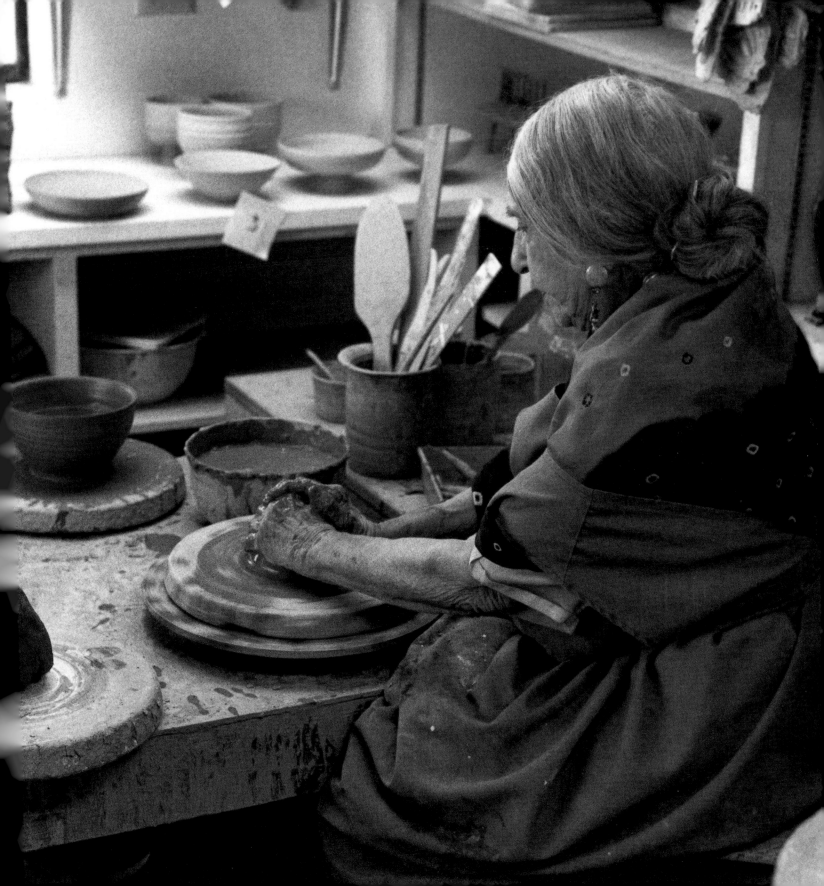

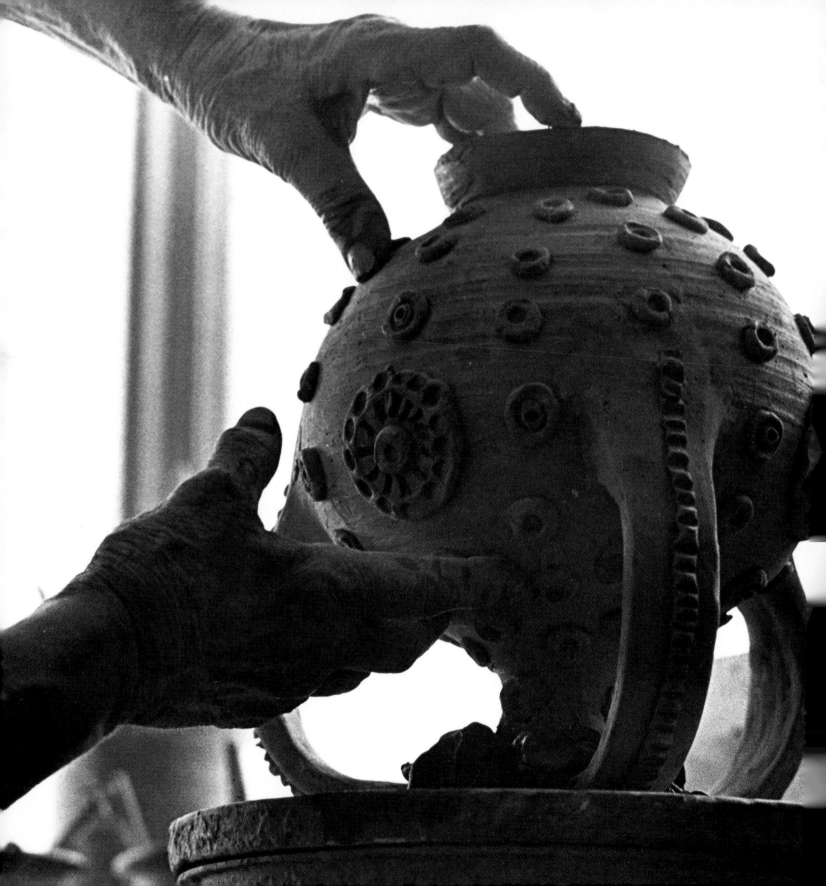

Six Luster Plates

Beatrice Wood did not consider making ceramics until 1933, when she was already forty years old. Wood not only wanted to become a potter, an achievement in itself at her age, but she wanted to take on luster glazing, one of the most mysterious, elusive, unpredictable, and extravagant techniques in ceramics. Unknowingly, she took the first step toward this gilded odyssey in 1930, while visiting Holland. She was there to hear the Indian philosopher Jiddu Krishnamurti speak at Castle Eerde in Ommen. Passing through the city of Haarlem on her way home, Wood stopped off to visit some antiques shops. She was captivated by a set of six nineteenth-century neo-rococo lusterware plates and purchased these for her trousseau.

Wood had been peripherally aware of ceramics from museum visits in her youth, but now she was drawn like a magpie to the glamour of the luster on the plates, a surface that is neither for the timid nor for the puritanical. It is a rich and decadent palette, a rainbow of shimmering gold, silver, copper, viridian greens, incandescent pinks, and intense purples. Lusterware dates from the Isnik Empire, in the eighth century, when Ottoman potters began to make vessels with glazes in imitation of precious metals.

This work entered Europe in the thirteenth century through the Moorish conquest of Spain, whose Hispano-Moresque wares then spread to Renaissance Italy, and the gilded, elegant platters of Gubbio and Detuta. It eventually reached the rest of Europe, although it was not as popular in the north. In the eighteenth century, British potters managed to industrialize luster glazing; in the process they both popularized and ultimately vulgarized the technique. The pottery used luster for decorative effect and to make silver-glazed earthenware teapots — molded from silver teapots — that were known as "poor man's Sheffield."

At the time Wood became enchanted with it, luster was not in vogue. It had enjoyed a fin de siècle revival in Britain, France, and Austria, where these liquid, lustrous glazes perfectly matched the opulence of the Aesthetic movement and the eroticism and decadence of Art Nouveau. In the 1920s it enjoyed something of a comeback, but mainly in commercial decorative wares where it was used to imitate metal. In the mid-1930s the two aesthetic poles within ceramic art were the modernist objectivity of "Machine Art" and, in contrast, the rustic brown stoneware glazes from the Anglo-Oriental school of Bernard Leach and his followers. Apart from Italy's Pietro Melandri, working in the pottery town of Faenza, no potters of any importance were pursuing lusterware at this time. Luster was considered passé.

None of this mattered to Wood, who had no inkling that she herself would soon be making ceramics and merely wanted to find a teapot to match the plates. Once she returned to her home in Hollywood, California, Wood began a fruitless three-year search, eventually conceding that the only solution was to make the teapot herself. Morgan Farley, a young actor, suggested that she enroll in the pottery class at Hollywood High School's Adult Education Department, where she expected to "make a teapot in twenty-four hours."[1]

OPPOSITE
Hands of the potter. Wood working on a pot, c. 1950.

Many weeks of labor resulted in only two crude plates ("absolute horrors," as Wood recalled them) and a pair of rudimentary but charming molded figures. To her amazement, she was offered $2.50 apiece for the figures. She made more and they also sold. Wood saw an opportunity to ease her difficult financial circumstances. The country was still in the grip of the Great Depression and Wood, unmarried and unemployed, was living on a monthly stipend of $73 from her mother. Beatrice was unambitious. She figured that even a modest production of only four figures a month would greatly supplement her income.

This was the pragmatic beginning for a career that grew to span seven decades, establishing Wood as one of the greatest exponents of lusterware in the twentieth century. A year after she died, the *New York Times Magazine* selected hers as one of the great lives of the century in a special feature that included profiles of, among a variety of others, Frank Sinatra, Jerome Robbins, and Roy Rogers! Michael Kimmelman wrote in the profile that Wood spent her life "running away from what she was supposed to have become and into the fickle arms of whimsy — and the arms of various men, exemplifying American Bohemianism in its sweetest, purest form."[2]

ABOVE
Checkerboard Luster Footed Vessel *(detail)*,
c. 1962, 8 $^{1}/_{2}$" h

OPPOSITE
Lavender Luster Footed Bowl, *1964, 6 $^{1}/_{4}$"h*

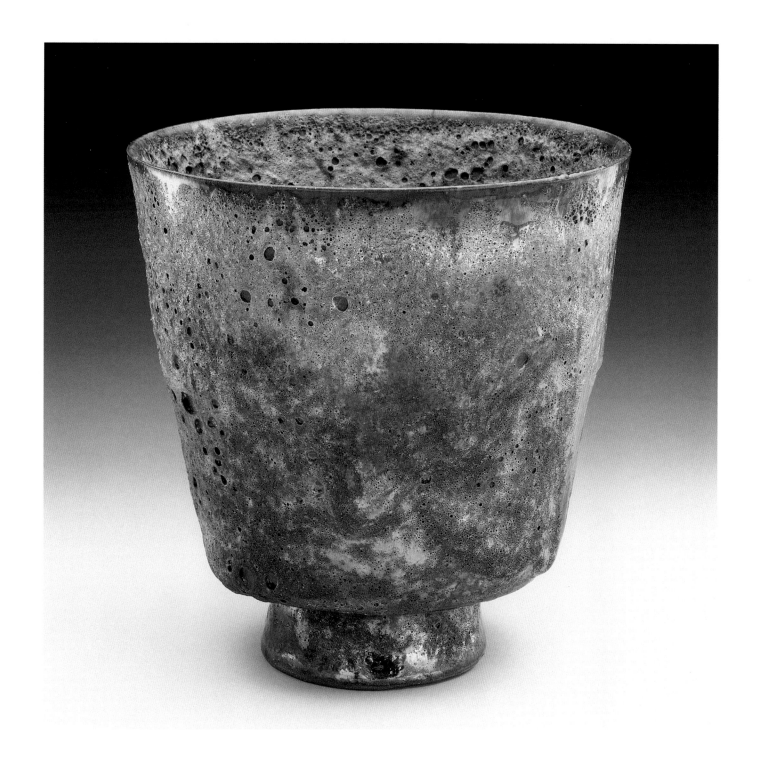

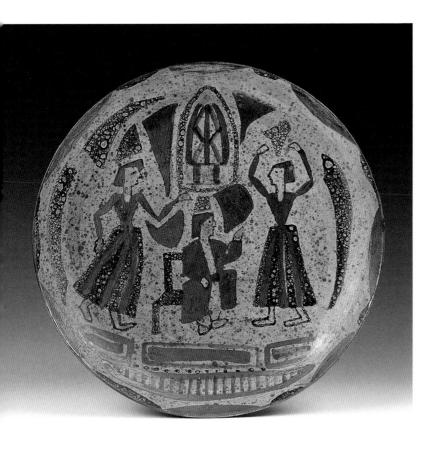

Egyptian Plate, *c. 1944,*
13 1/2″ d

Cat with Leaves Plate,
1957, 11 1/4″ d

OPPOSITE
Bottle, *1969, 7″ h*

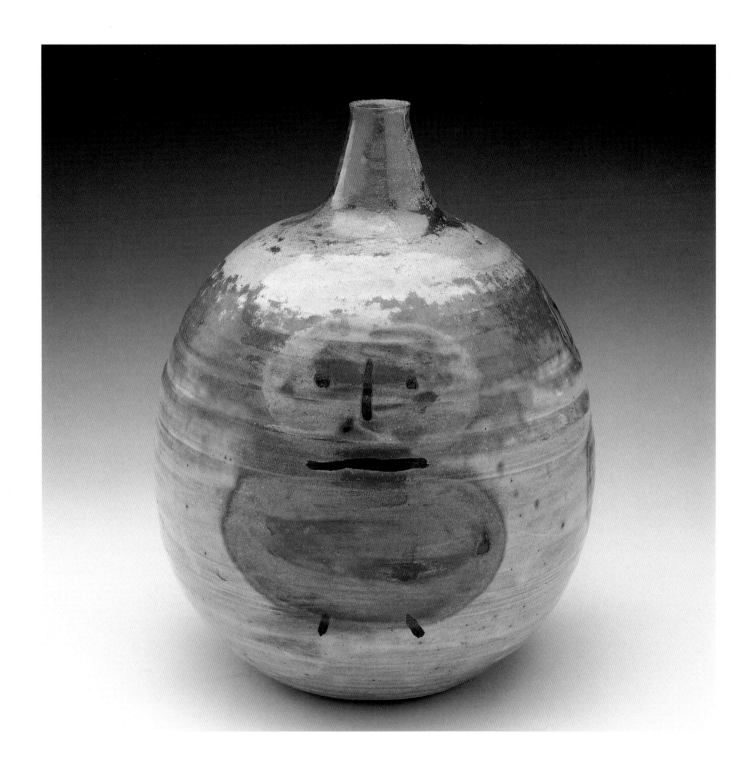

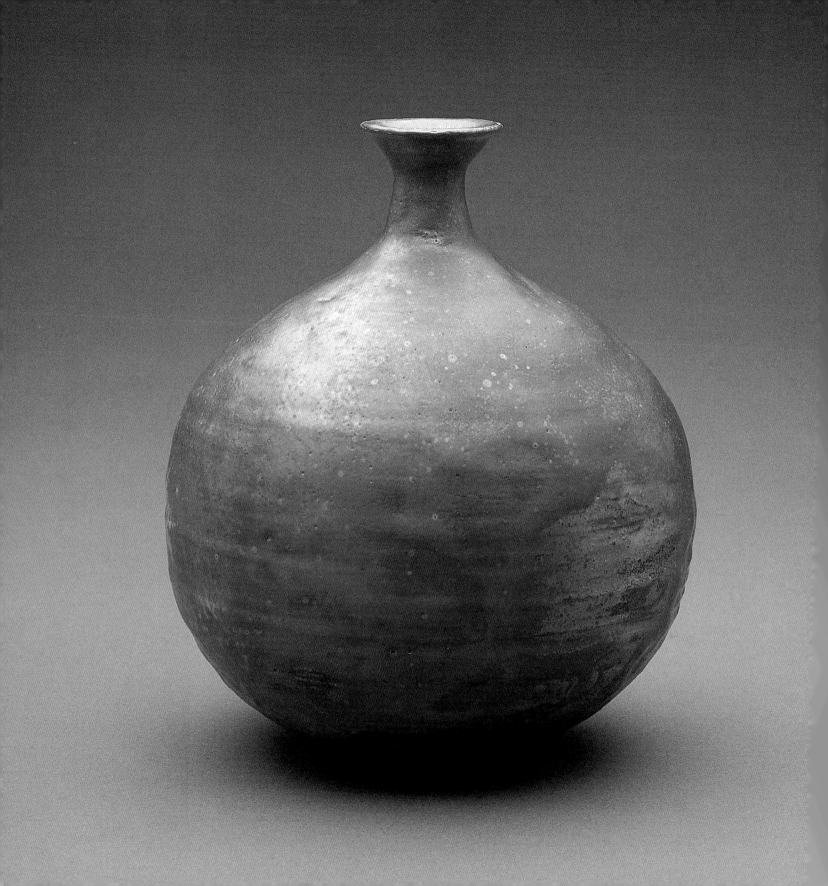

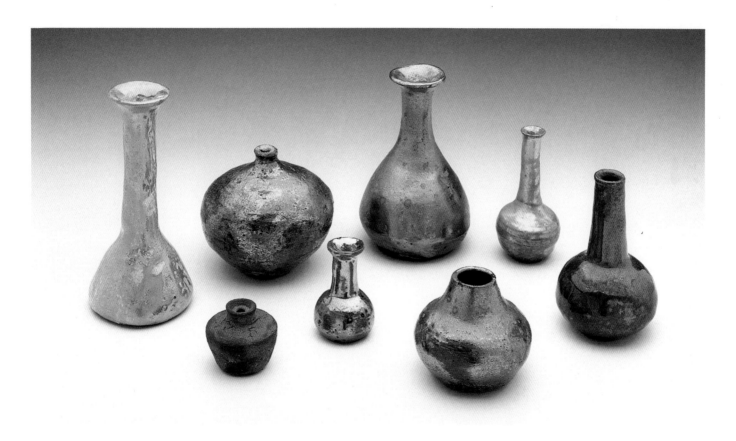

Eight Miniature Vessels, *c. 1980, 1″–4″ h*

OPPOSITE
Bottle, *1978, 7³/₄″ h*

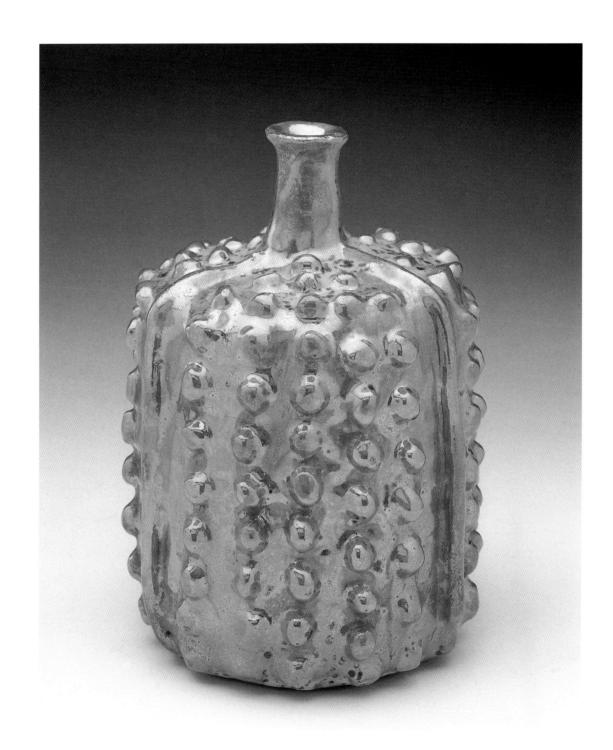

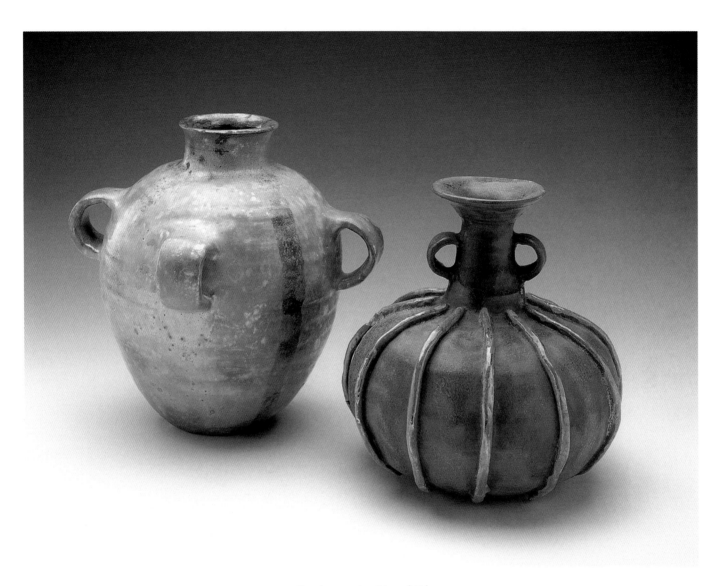

Bottles, *c. 1965, 6¹/₂″ and 6″ h*

⊶⊷

OPPOSITE
Gold Luster Beaded Bottle, *1990, 4³/₄″ h*

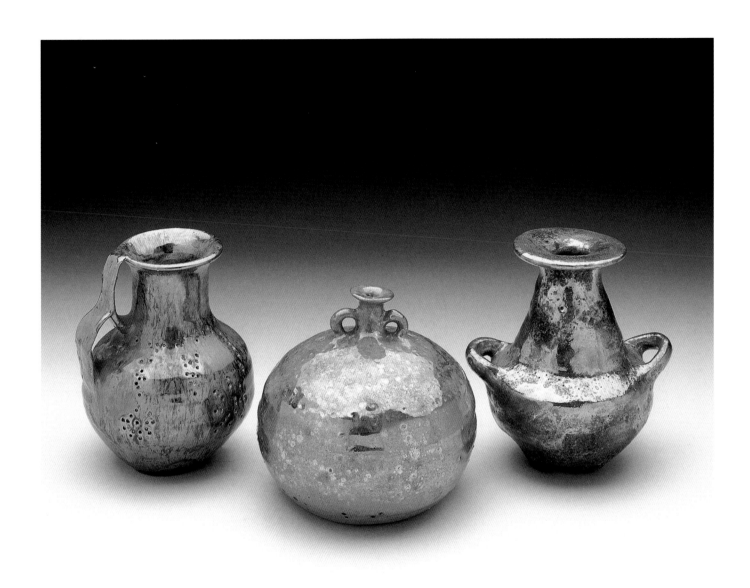

ABOVE
Three Miniature Vessels, *c. 1978, 4 1/8″, 4″, and 4 1/8″ h*

OPPOSITE
Bottle, *1983, 7″ h*

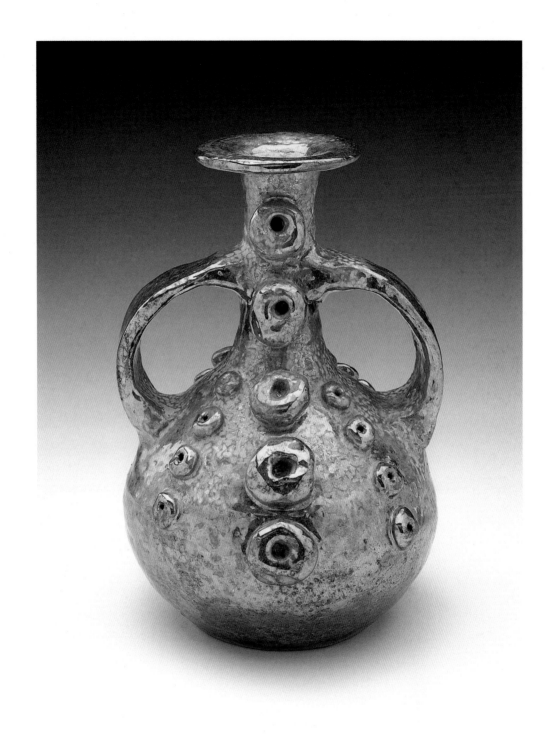

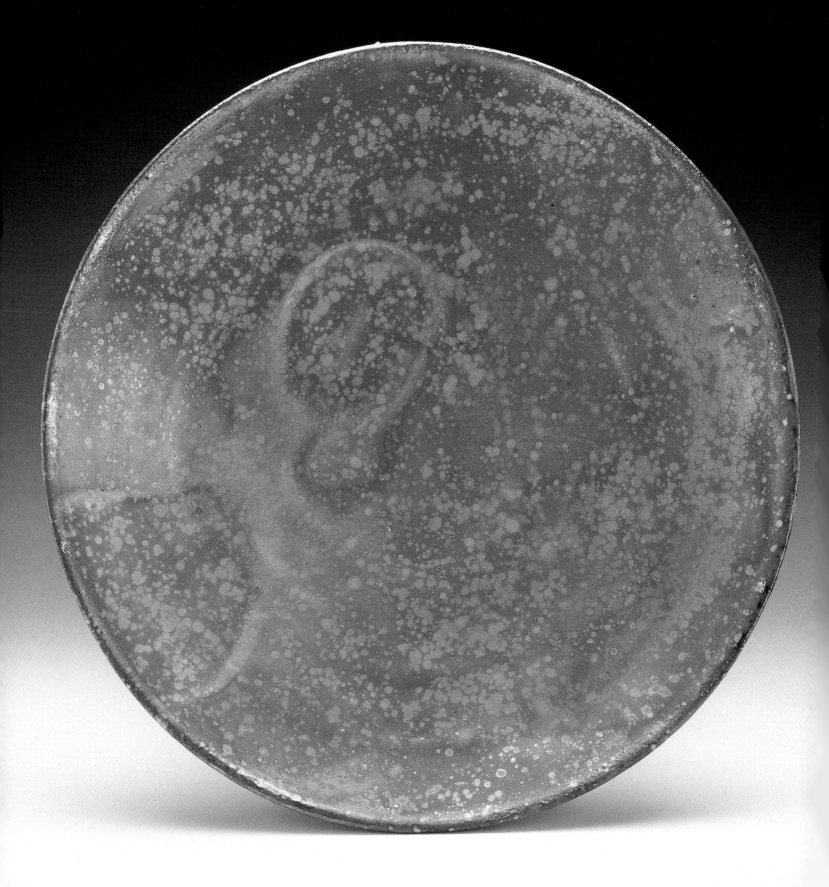

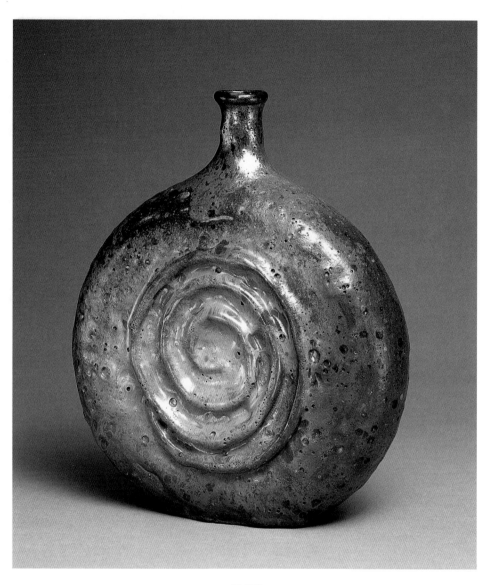

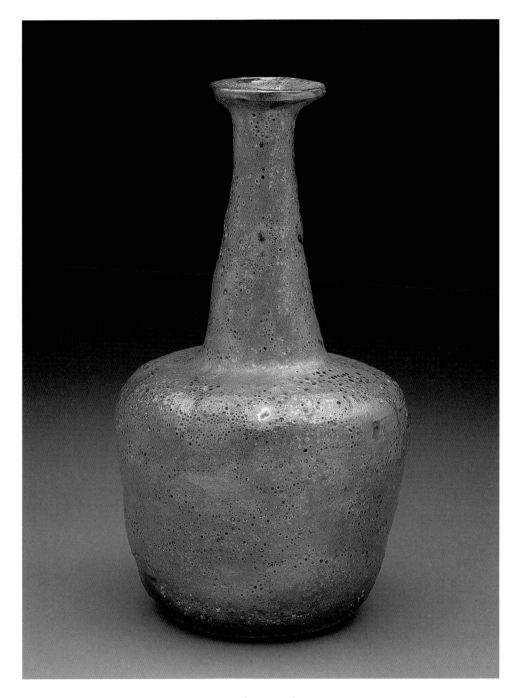

Bottle, *1987, 9˝ h*

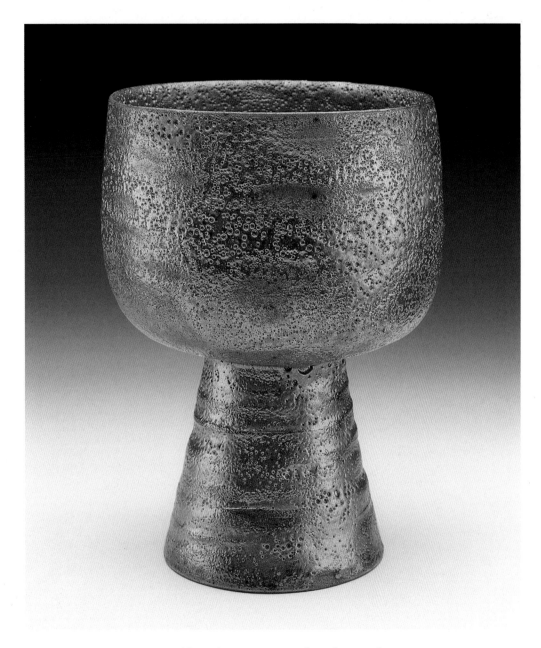

Gold Rainbow Luster Footed Bowl, *1965, 8″ h*

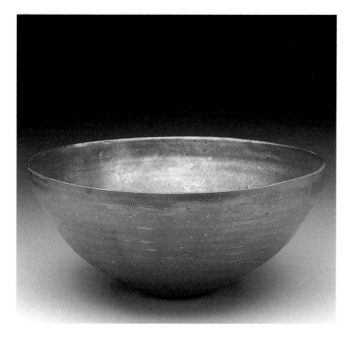

Luster Bowl, *c. 1984, 4″ h*

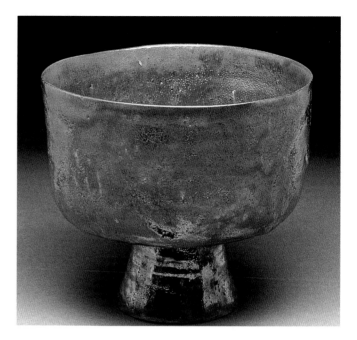

Footed Bowl, *c. 1984, 7″ h*

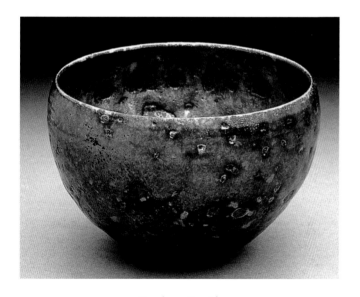

Bowl, *c. 1984, 3″ h*

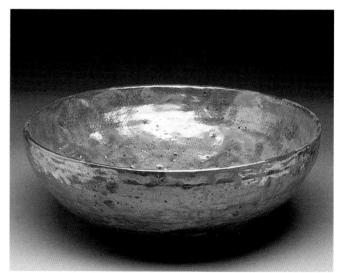

Bowl, *c. 1984, 4″ h*

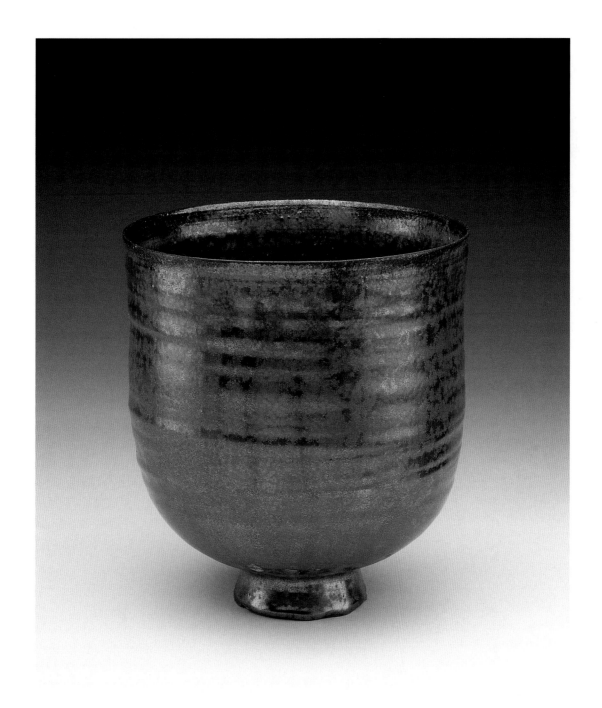

Blue Luster Footed Bowl, *1962, 5″ h*

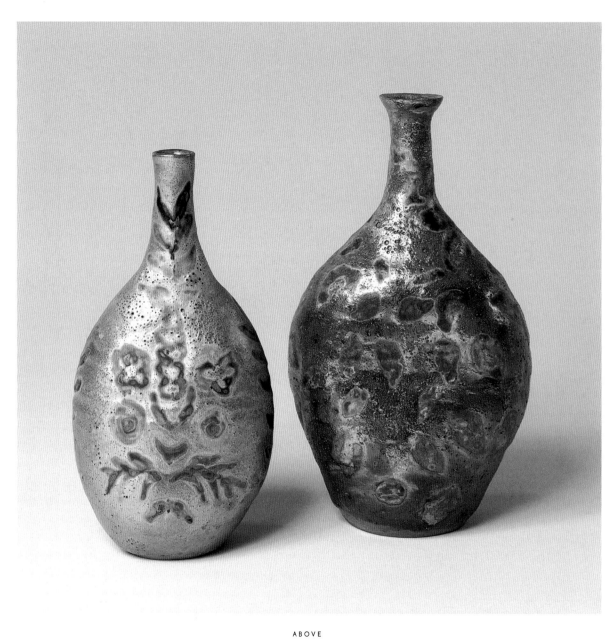

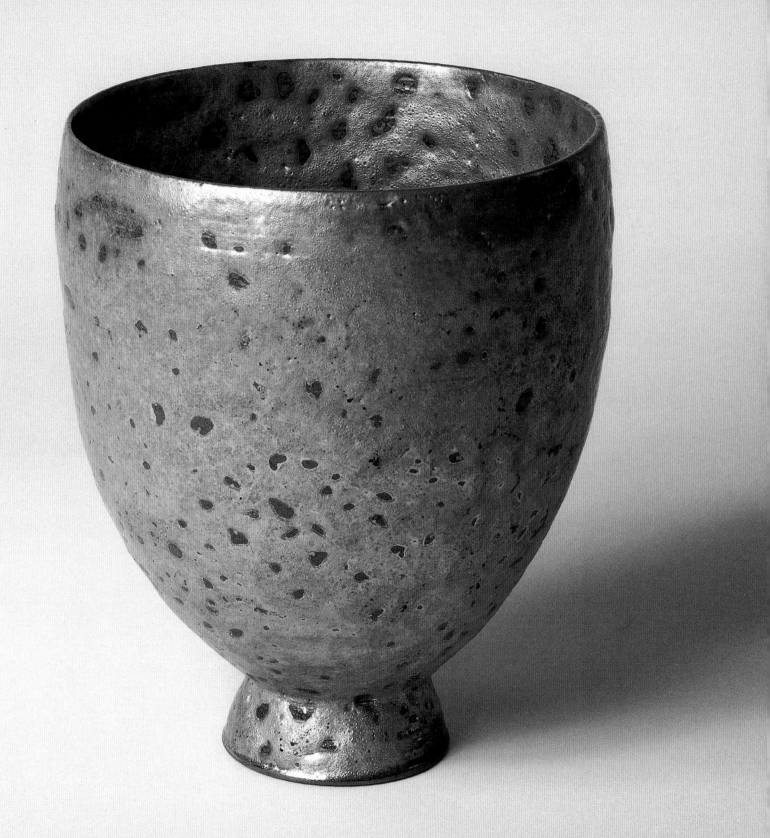

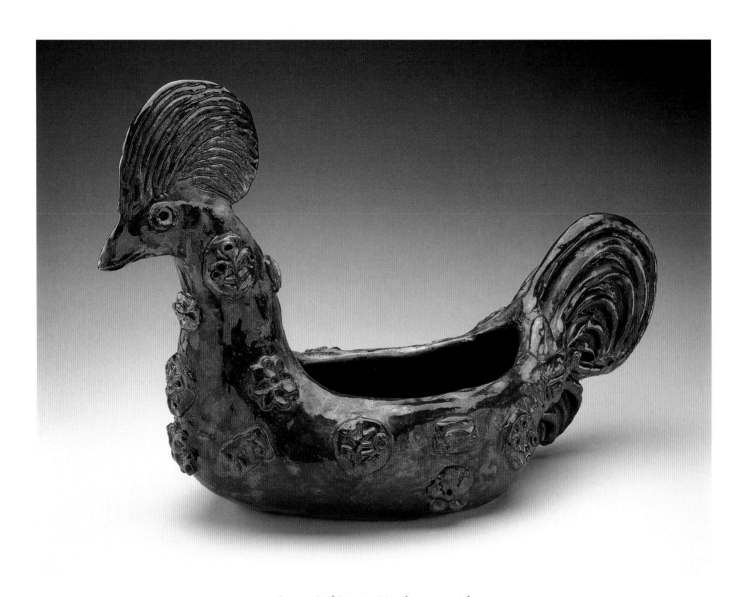

Copper Red Rooster Vessel, c. 1980, 9¹/₂"h

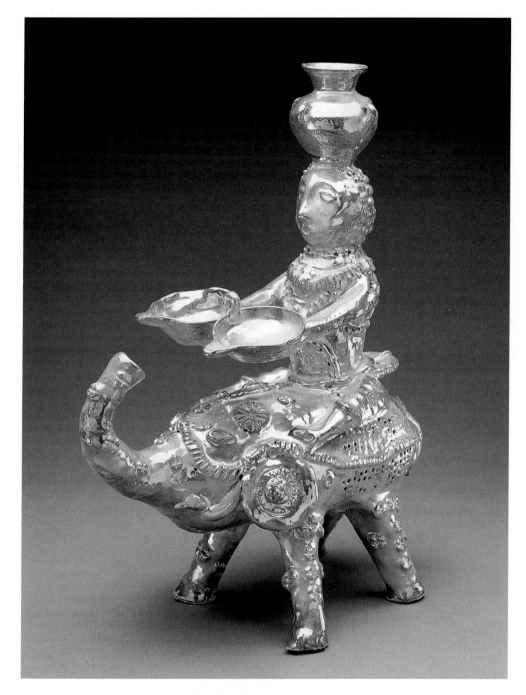

The Gold Elephant, *1984, 14″ h*

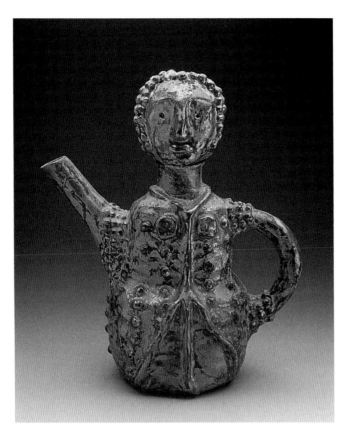

Woman Teapot, *1984, 10″ h*

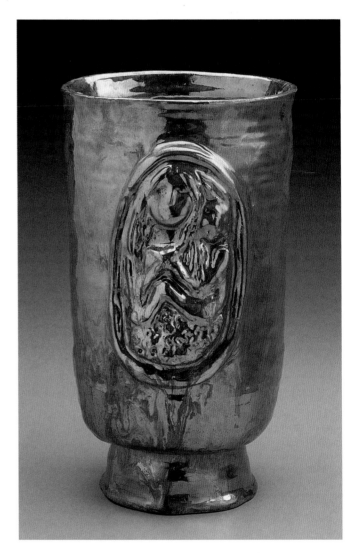

Tall Footed Vessel, *1988, 10″ h*

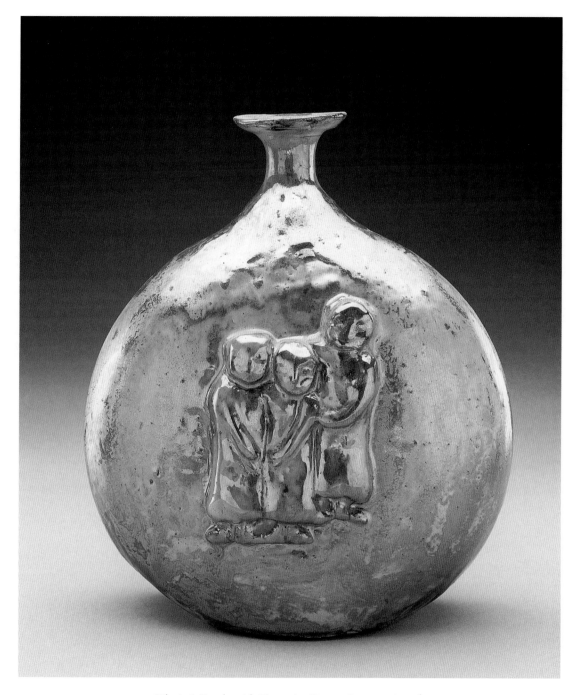

Pilgrim's Bottle with Figurative Decorations, *c. 1985, 8˝ h*

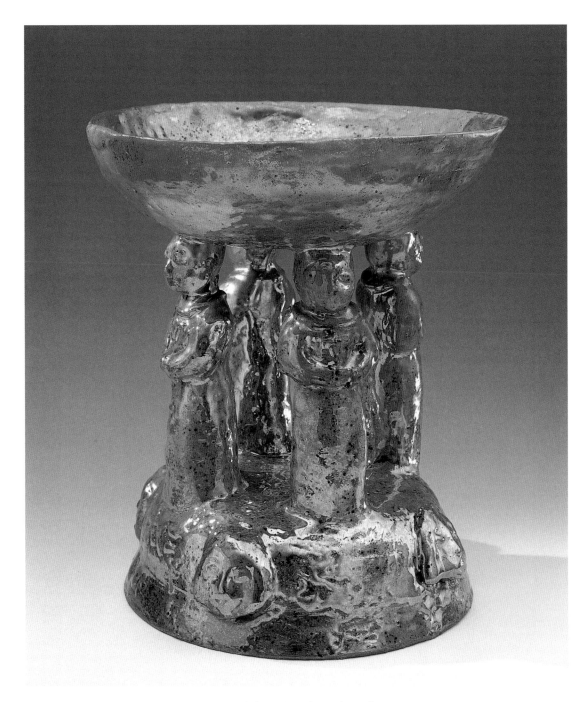

Four Column Vessel, *1995/97, 13″ h*

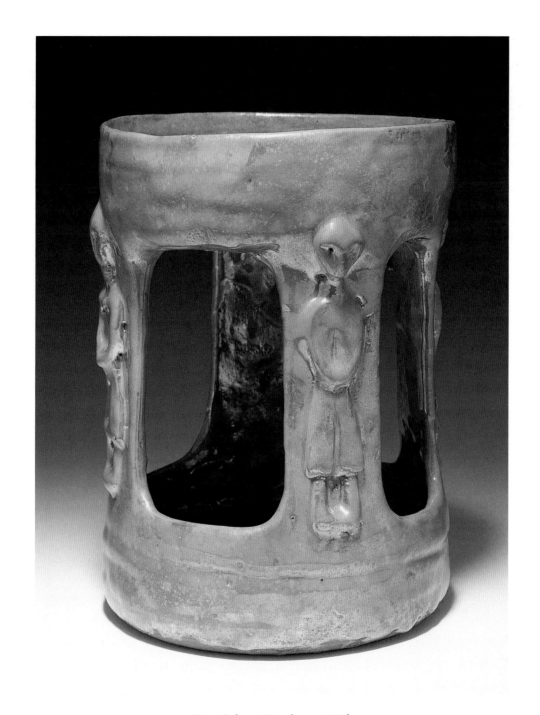

Four Column Vessel, *1995, 9³/₄″ h*

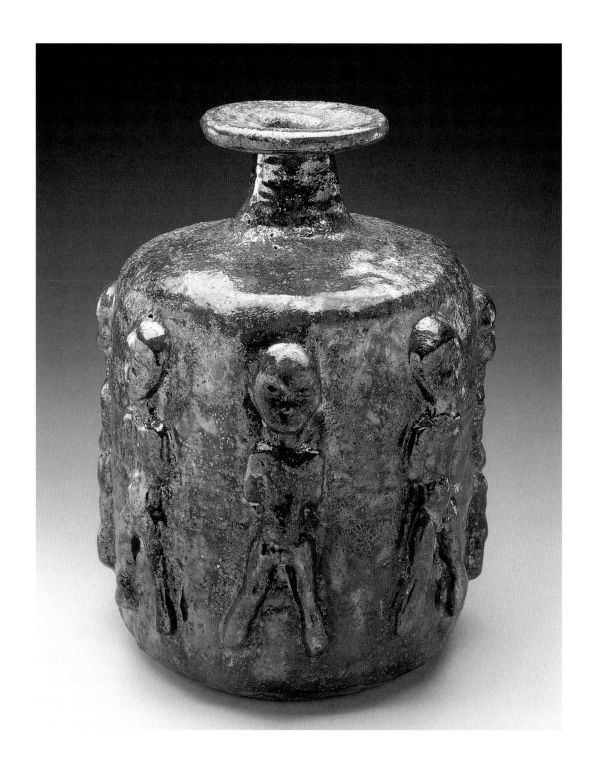

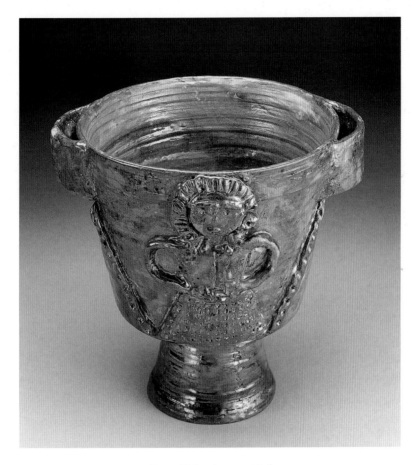

Footed Vessel, *1959, 9¹⁄₂″ h*

OPPOSITE

Large Luster Bottle with Figures, *1978, 12″ h*

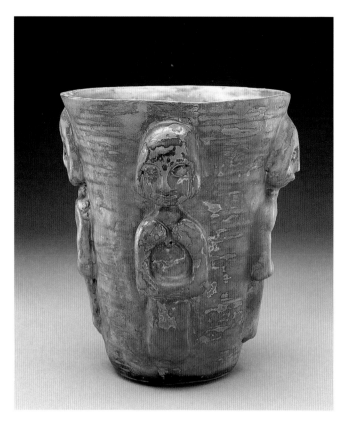

Vase with Primitive Figures, *1984, 10" h*

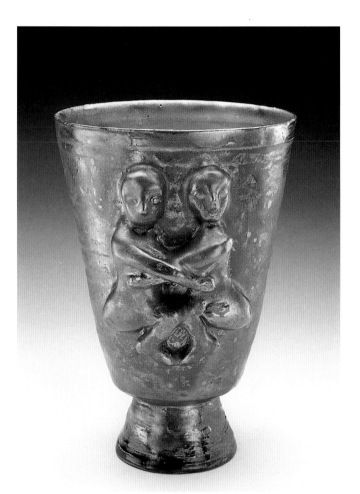

Footed Cup, *1989, 12" h*

OPPOSITE
Footed Bowl with Figures, *c. 1988, 6¹/₂" h*

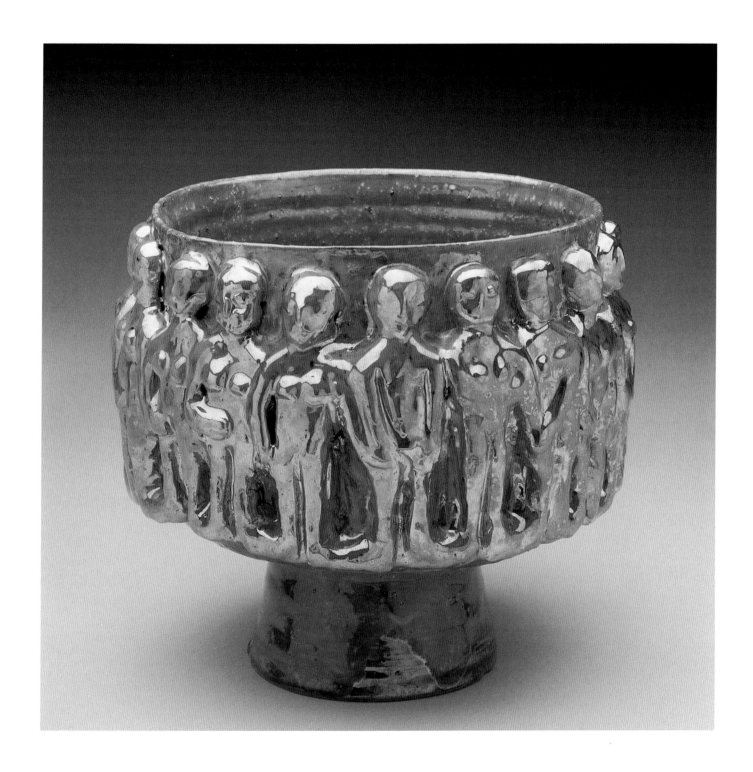

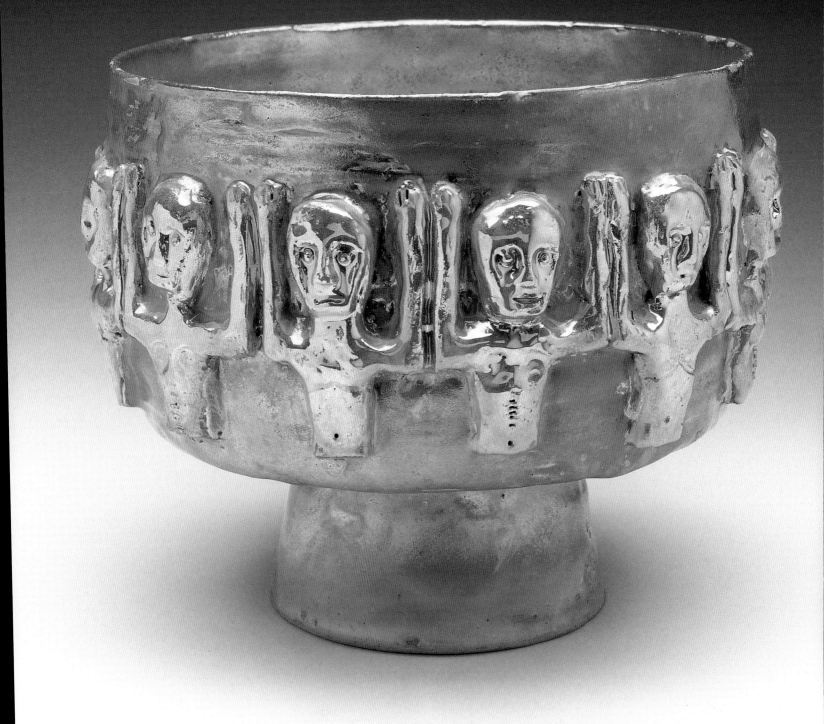

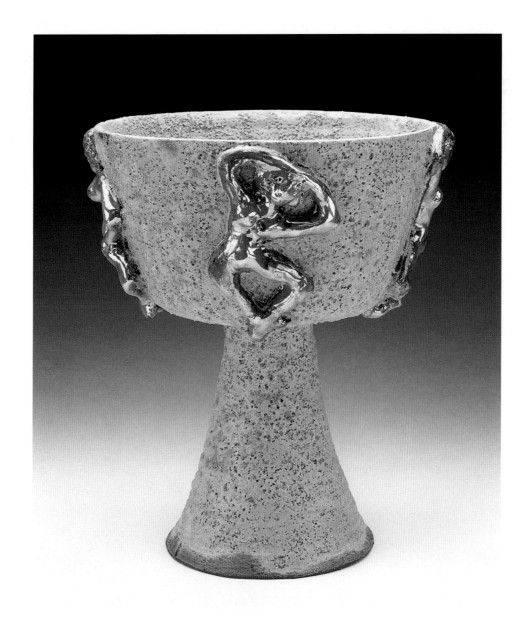

Chalice, *1993, 10˝ h*

Gold Luster Footed Bowl with Band
of 12 Luster Figures, *c. 1985, 7 ¹/₂˝ h*

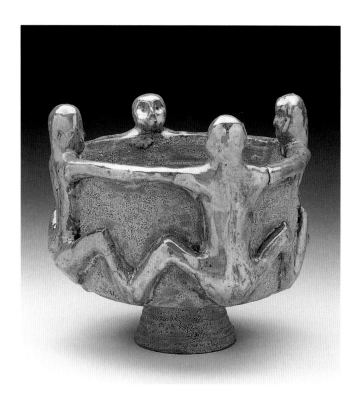

Turquoise Matte Footed Bowl, *1992, 7¹⁄₂″ h*

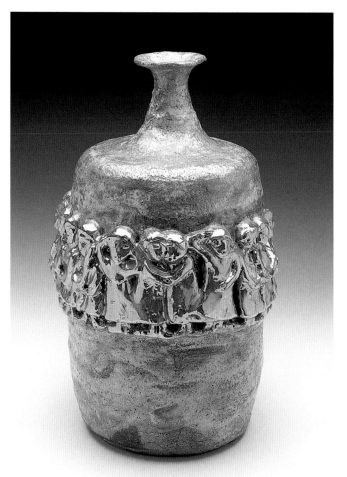

Bottle with Figures, *1989, 14″ h*

OPPOSITE
Husband and Wife Teapots, *1984,
man 19″ h; woman 17″ h*

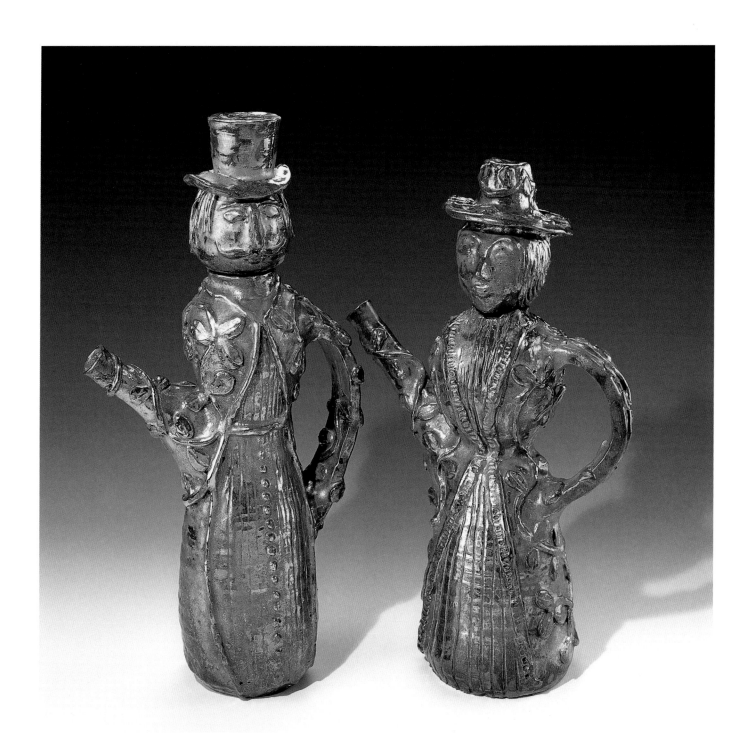

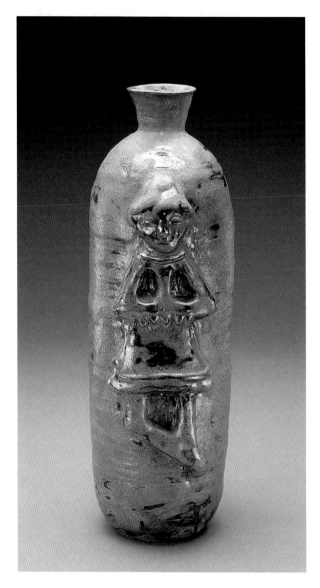

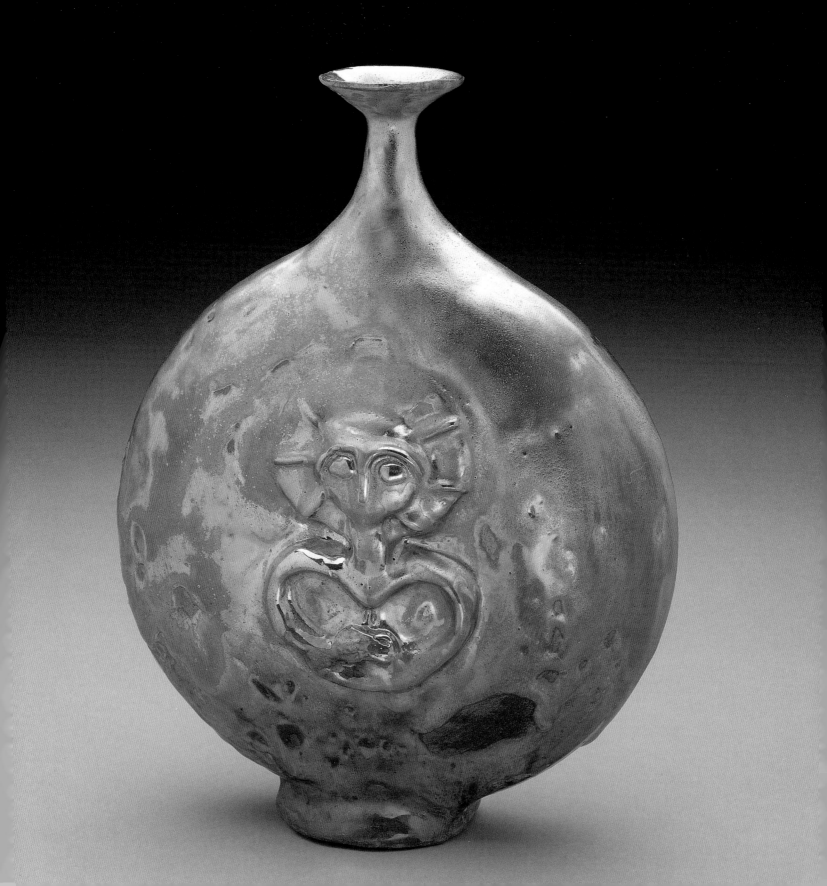

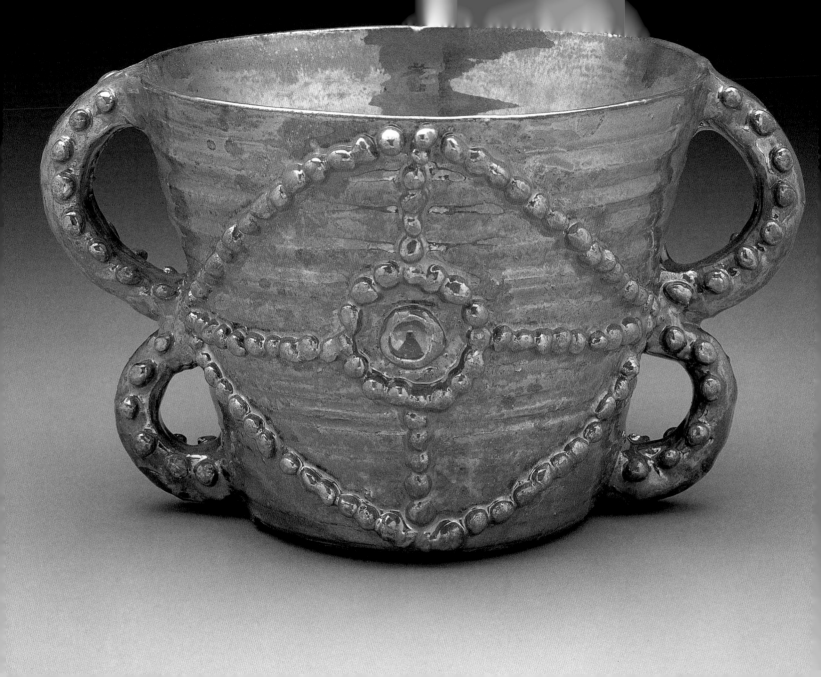

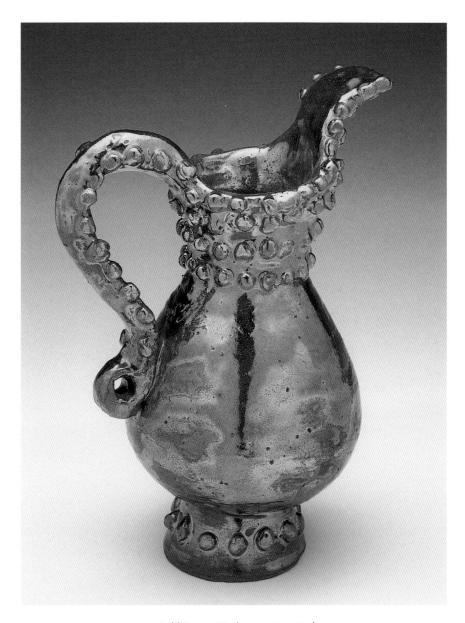

Gold Luster Pitcher, *c. 1985, 7 ¼″ h*

—•—

OPPOSITE
Double Handled Bowl, *1987, 5 ¼″ h*

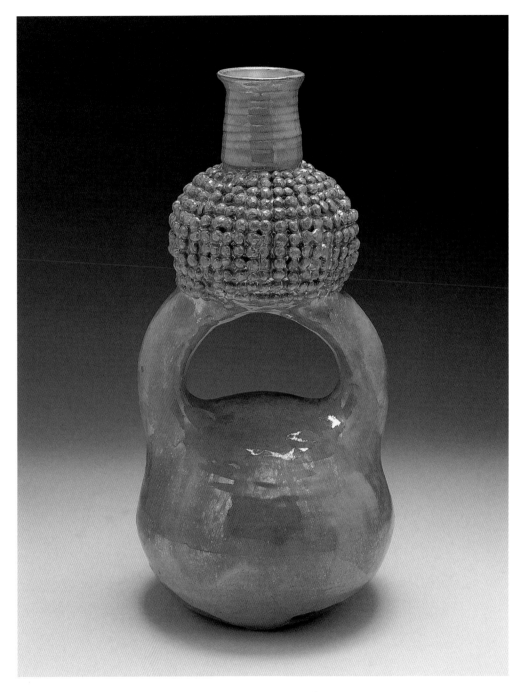

Stirrup Pot, *1993, 12¹/₂″ h*

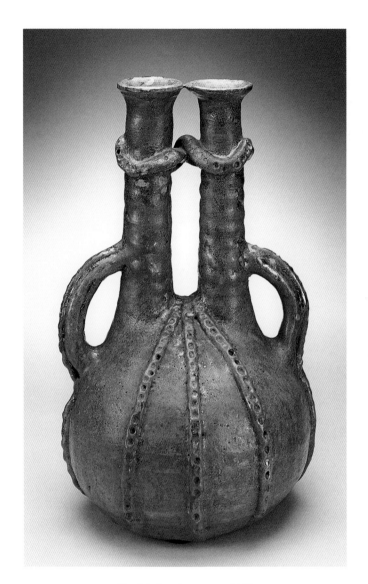

Double Bottle, *c. 1970, 9³/₄″ h*

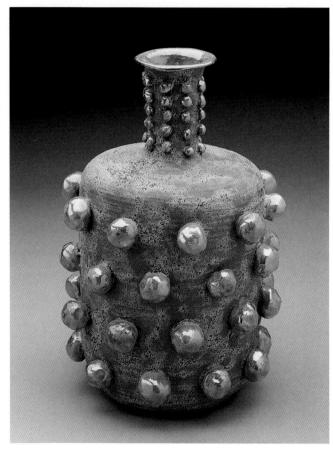

Bottle, *1989, 11″ h*

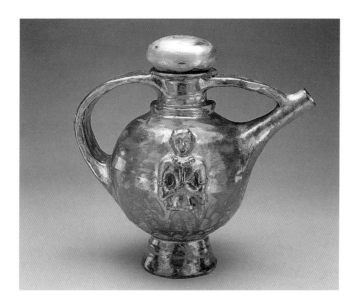

Blue/Green Luster Teapot, *1989, 13″ h*

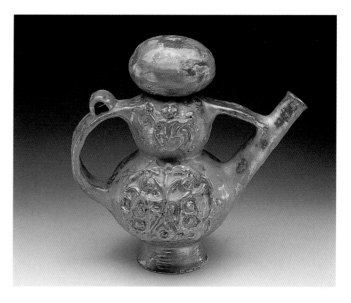

Luster Teapot, *1988, 11¹/₂″ h*

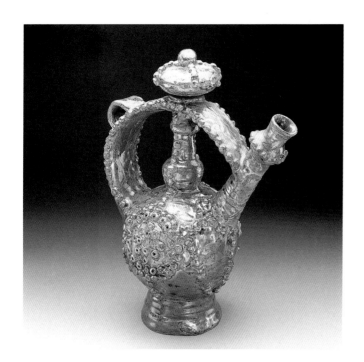

Beaded Teapot, *1990, 10″ h*

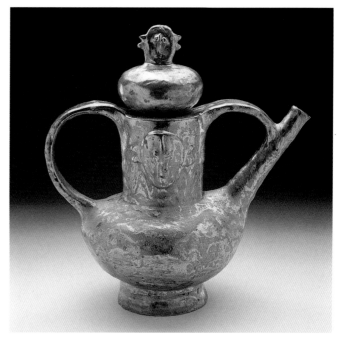

Teapot with Figure Lid, *1988, 13¹/₂″ h*

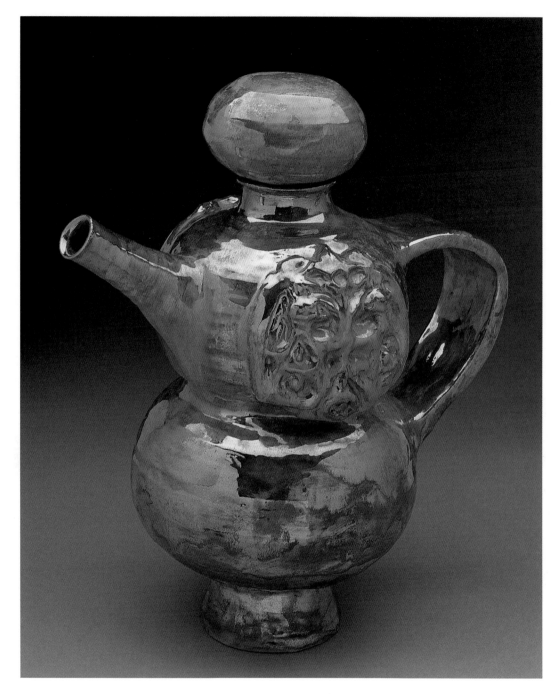

Teapot, *1988, 14˝ h*

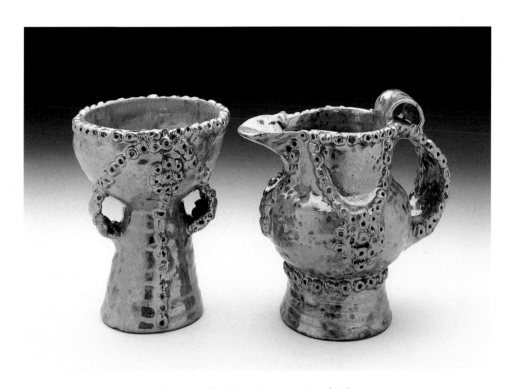

Two Handled Vessels, *1992, 5¹/₂″ and 6″ h*

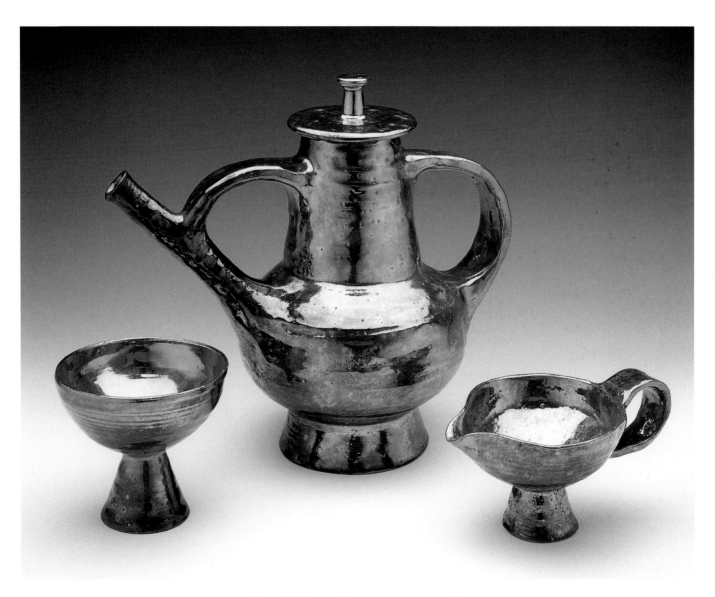

Blue Gold Luster Teapot, c. 1980, teapot 9¹⁄₂″ h;
sugar bowl 3¹⁄₂″ h; creamer 3¹⁄₄″ h

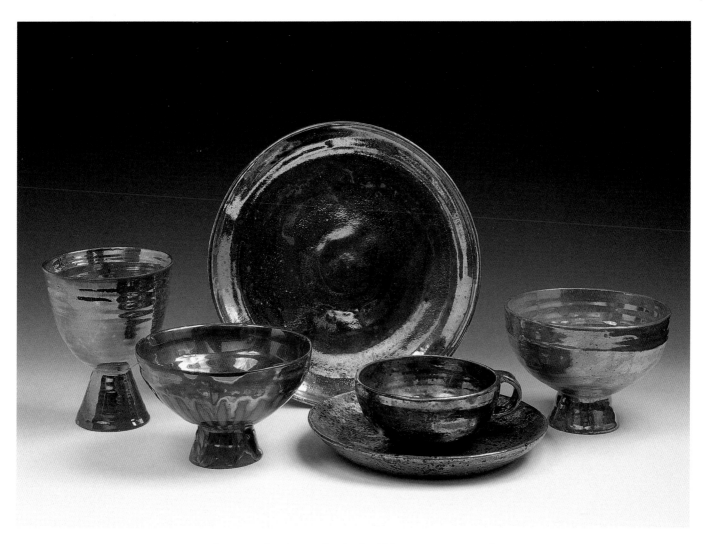

Place Setting from Dinner Service for Eight, *c. 1982 – 92, 4″ – 9″ h*

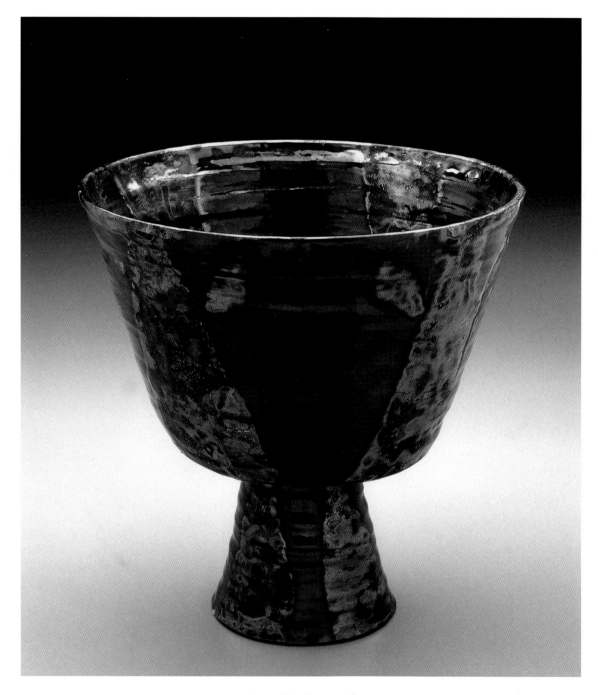

Footed Bowl, *1987, 9″ h*

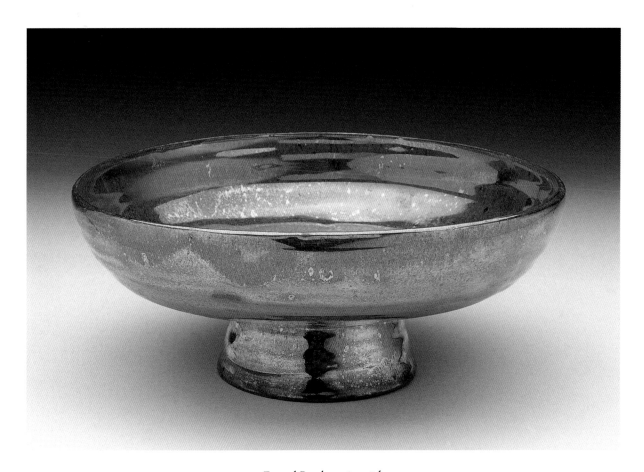

Footed Bowl, *c. 1983, 11″ d*

•———•

OPPOSITE
Luster Vessel, *1986, 8″ h*

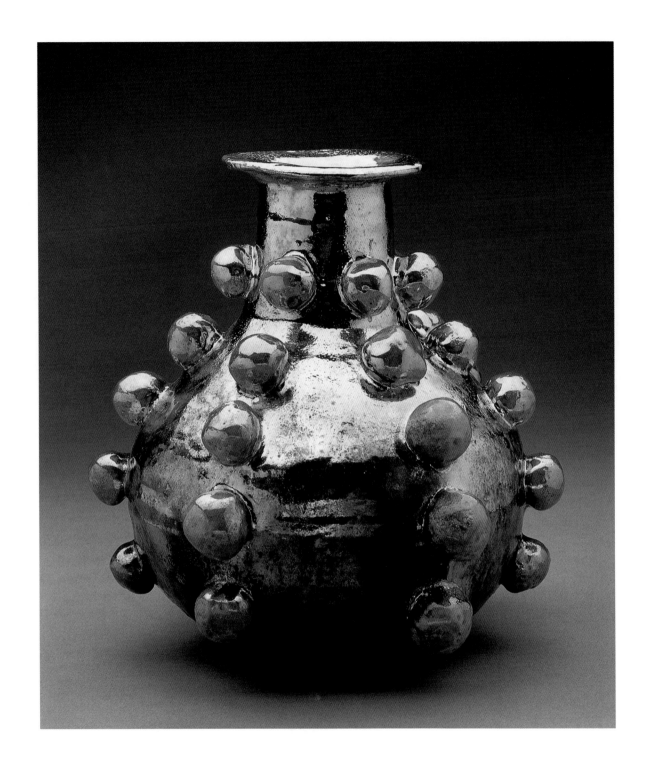

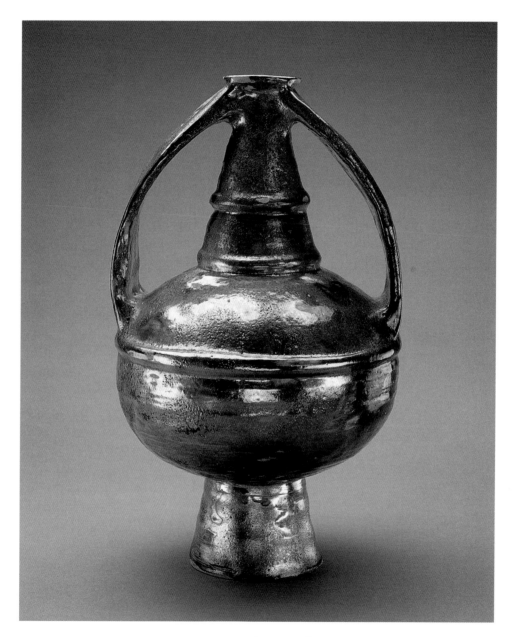

Luster Bottle, *1987, 13″ h*

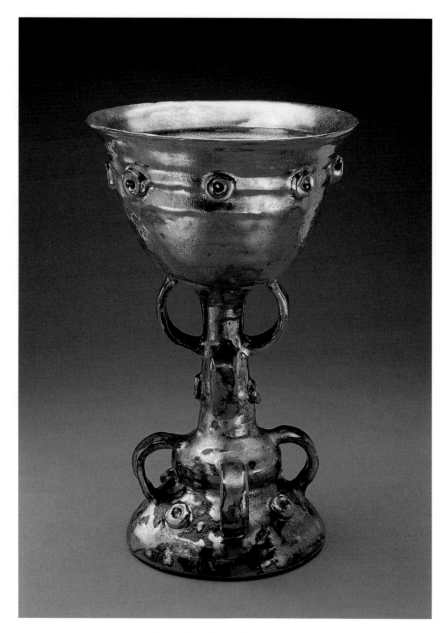

Blue and Gold Chalice, *1987, 11″ h*

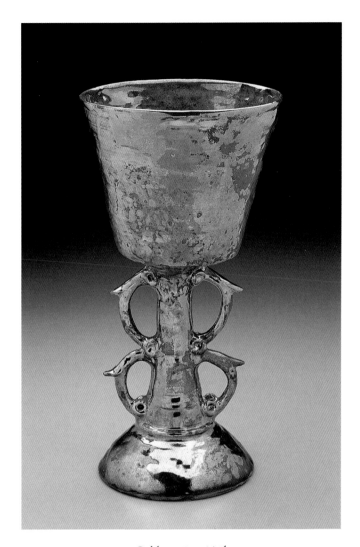

Goblet, *1987, 13 ¼″ h*

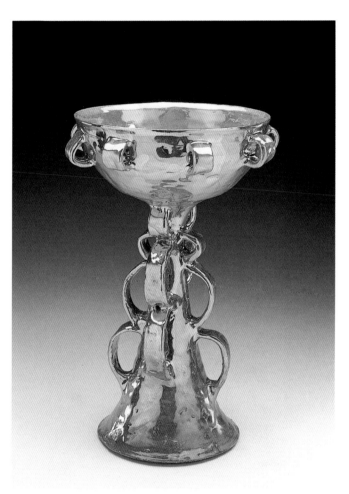

Chalice with Rings, *1989, 12″ h*

OPPOSITE
Gold Chalice, *1992, 10″ h*

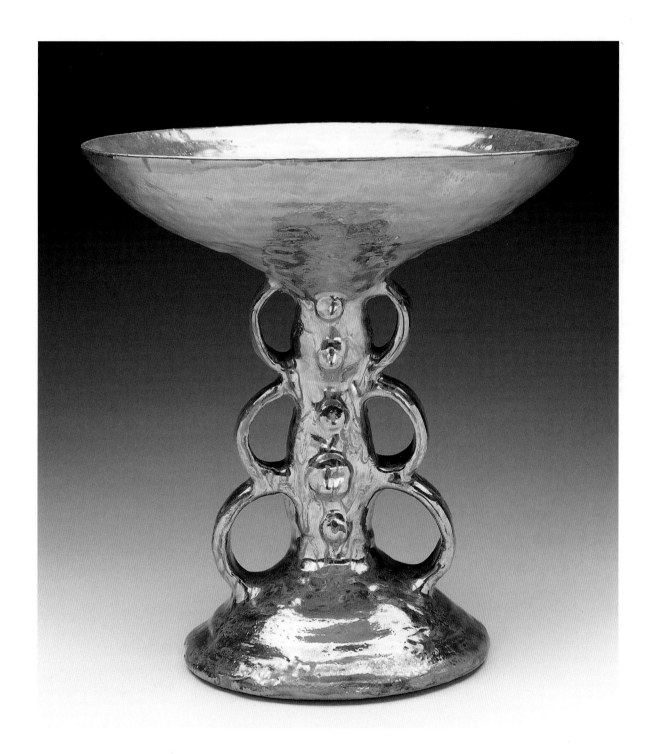

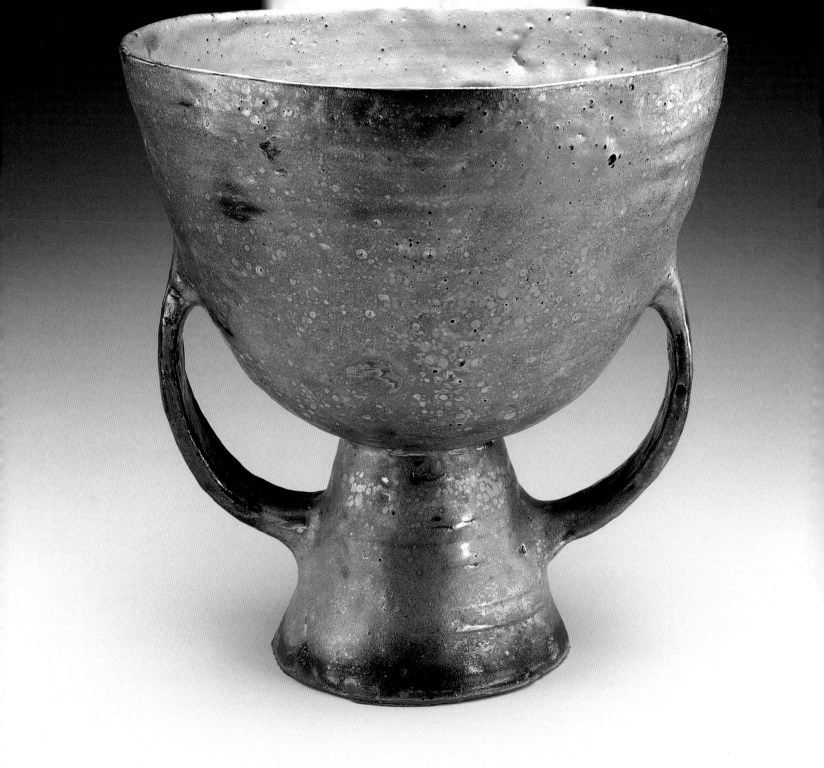

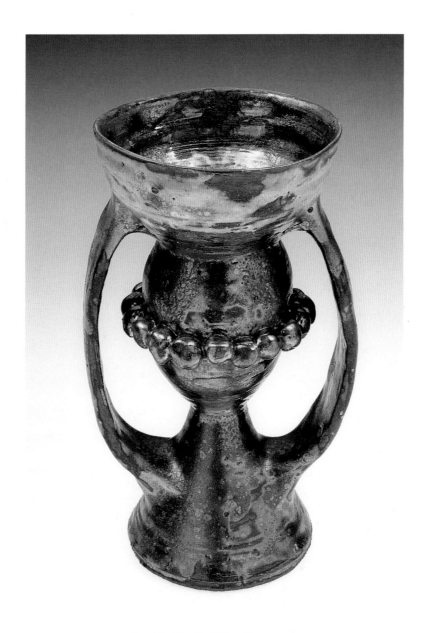

Double Handled Vessel, *1982, 11″ h*

———•—•———

OPPOSITE
Double Handled Luster Vessel, *c. 1990, 12″ h*

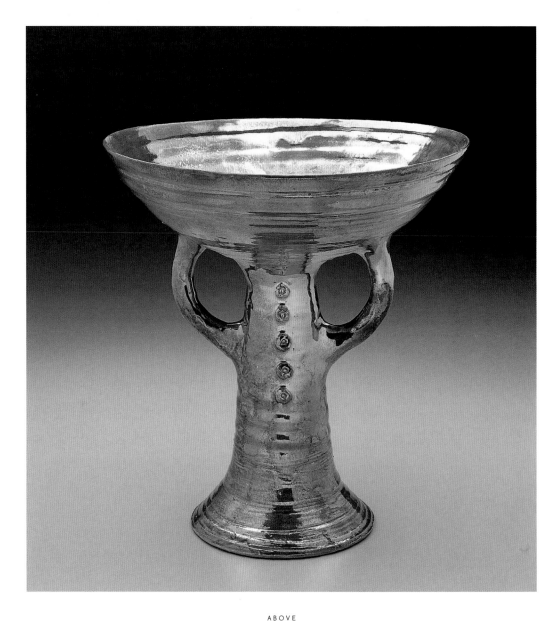

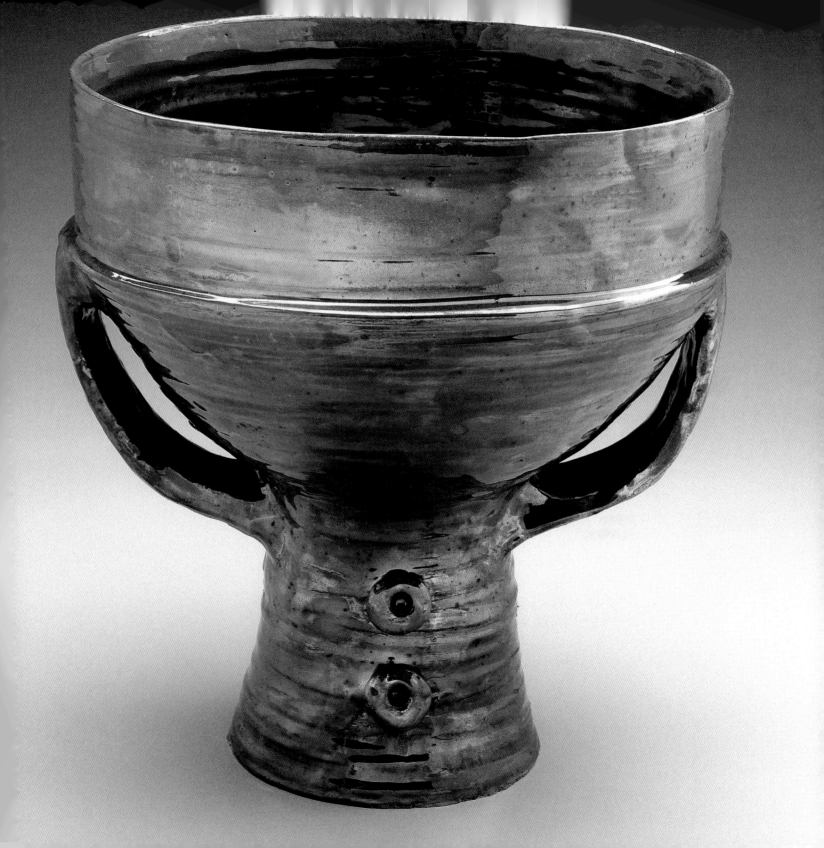

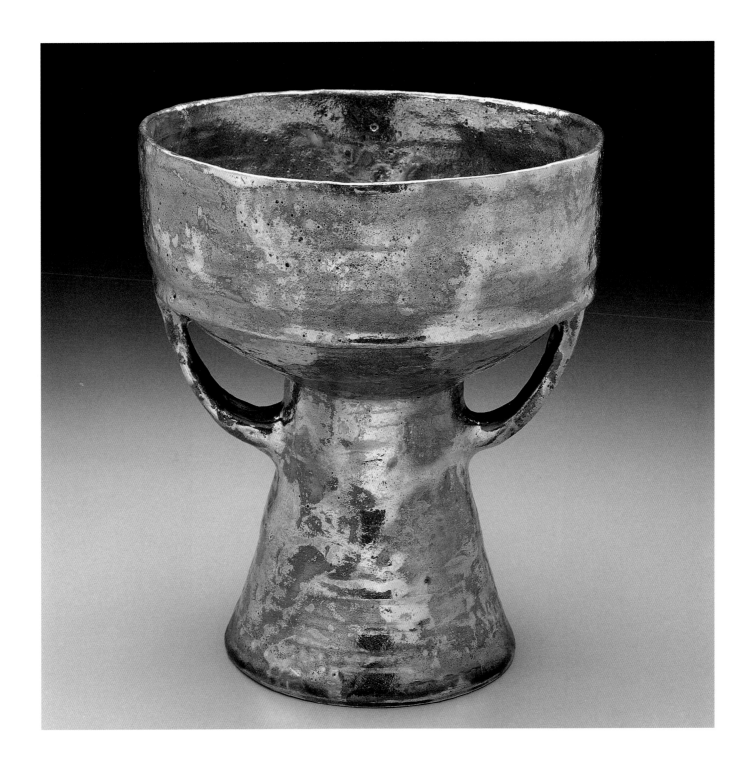

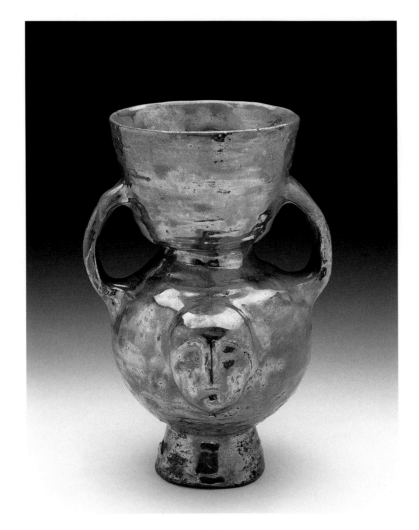

Double Handled Chalice with Masks, *1995, 9 1/4″ h*

Luster Urn, *1987, 14 3/4″ h*

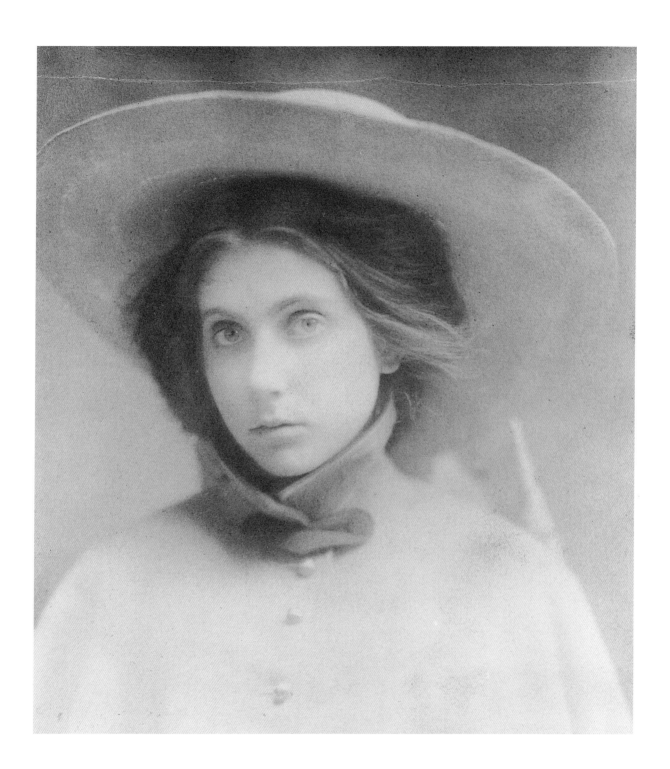

[1]

LACE COLLARS AND ERMINE TRIM

Photographs of the infant Beatrice show her dressed exquisitely in outfits trimmed with lace and ermine. She was born in 1893 in San Francisco to a well-connected family. Her mother, Caroline ("Carera") Wood, was socially ambitious. She had grand plans for her daughter, which became even grander with the family's move to New York in 1898. Beatrice's father, Benjamin Wood, was a successful real estate broker, mild mannered, indulgent, and content to leave the job of raising his daughter and younger son to his wife.

Mrs. Wood focused on Beatrice's education with the goal in mind of her eventual "coming out" to New York society. At the age of seven she spent a year in a convent in Paris, learning French, and later was enrolled in Ely School, then the most fashionable finishing school in New York City. In 1910 Wood attended Shipley School in Bryn Mawr, Pennsylvania. Wood's formal education was rounded out with frequent trips to Europe. Accompanied by her mother, she regularly visited art galleries and museums and attended the theater.

However, Mrs. Wood's relentless campaign to turn out a dutiful debutante was not successful. As Elizabeth Hapgood, Beatrice's longtime friend, later wrote, "Mrs. Wood was a woman of great energy, excellent taste in furniture, an elaborate collector of beautiful things from laces to credenzas, but she had little sense of the inner longings of her shy but gifted daughter."[3] Exposure to the arts stirred a sense of independence and rebellion in the seemingly

Beatrice on a trip to Paris with her mother, 1903.

meek but intensely romantic young girl, who had fallen deeply in love with the bohemian world of the arts.

In 1912, to her mother's great dismay, Beatrice rejected plans for a coming-out party and announced that she would become a painter. Nineteen years old and still supervised by a full-time chaperone, she moved to France to study painting at the Julien Academy in Paris. But Wood soon discovered that the academy, once an exciting and progressive school, had degenerated into a tediously academic institution. She left Paris and set herself up in a garret in Giverny, Monet's hometown and a fashionable center for aspiring artists. There she played at being an artist producing "a still life in the morning, a landscape in the afternoon and an imaginary fantasy in the night." As Wood recalled, they were "all disasters, but it did not matter."[4]

Her vigilant mother soon returned her to Paris and placed her under the guidance of Madame Muszka, mother of one of her friends from the Shipley School. Muszka was a grand, theatrical woman who saw herself as the unofficial den mother to the international student community in Paris—mainly Russians, Chinese, Poles, and Serbs. She held regular lively afternoon teas, where the students could meet, talk, and perform, and balls, which they attended in their national costumes, most likely the source of Wood's lifelong love affair with exotic ethnic dress.

Having lost the passion for painting, Wood now turned to theater. She took private acting

OPPOSITE
Beatrice Wood at 15.

and dance lessons with members of the *Comédie Française,* who arranged for her to appear in crowd scenes on this legendary stage with Sarah Bernhardt and other stars of the company. Paris was beginning to deliver everything that Wood had hoped for: a budding career, an exciting social circle, and frequent visits to theater and dance. One of the highlights was attending the infamous premiere of Vaslav Nijinsky's *La Sacre du Printemps* in Paris. (Later, in New York, having learned Georgian folk dances from Klyustin, Anna Pavlova's maître de Ballet, Wood had the opportunity to dance in front of Nijinsky himself.)

This Parisian idyll was cut short by political turmoil in Europe, and Wood's parents summoned her back to New York just before the outbreak of World War I. Mrs. Wood did all she could to thwart her daughter's plans for a career on the New York stage. She allowed Beatrice to perform dances in public, but only as an amateur, believing it was immoral for a woman to dance for money. Eventually, in 1916, Wood's fluency in French enabled her to join the French National Repertory Theater (*Théâtre Français*) in New York. Her mother reluctantly agreed only because of her oddly Francophilic pretension that acting in French raised Beatrice above the level of a common thespian. However, Beatrice had to agree to appear under the stage name "Mademoiselle Patricia," so as not to taint the family name and reputation. Wood's first major role was as Eglantine in *Les Deux Sourds* in December 1916. Well received by the critics, she played more than sixty ingénue roles over the next two years.

In the same year, Alissa Frank, a bohemian journalist, introduced Wood to a French diplomat named Henri-Pierre Roché, a cultivated writer and art collector with a penchant for the avant-garde. He is best known today for his novel *Jules et Jim* (made into a memorable film in 1961 by François Truffaut), whose three protagonists were supposed to have been loosely modeled on Roché himself, Wood, and Marcel Duchamp. The legend is not true; however, Roché did write a second book, *Victor,* unfinished and unpublished for many years, in which the central female character was indeed based on Wood.[5] Roché was Wood's first lover, a tender and compassionate man who was her entrée into a progressive, modernist world of art, and who also encouraged her to explore her own creativity. Roché had credited himself with launching the career of another of his lovers, Marie Laurencin, and hoped now to achieve the same success with Wood.

Roché also taught Wood her first lesson about men and fidelity. When he casually admitted to sleeping with a mutual friend, Wood was devastated. She wrote that when "the bowl that was my heart was broken, laughter fell out."[6] Raised in a sheltered bourgeois environment, she had expected to fall in love, marry, and spend the rest of her life with the man of her dreams. But the men in the bohemian circle to which Roché had introduced her placed little value on middle-class morality, and Wood later bemoaned the misfortune of being born a "monogamous woman in a polygamous world."[7]

Having dispensed with her virginity (or her "honor," as it was referred to in those days), Wood experimented briefly with sexual freedom while working the vaudeville circuit. She became attracted to an acrobat who was appearing on the program with her. To be more precise, it was his erotically muscled neck and shoulders that was the object of her passion. She spent the night with him, but the next morning he "ate food off his knife and called me 'Cookie,' so that was the end of that!"

Wood soon became disillusioned with the games of promiscuity and vowed to give herself only for love. This did not prove to be an insurmountable hurdle: Wood, a hopeless romantic, was frequently in love. As she laughingly remarked, "If a man says he loves me, I fall into his lap like a ripe grape."[8] Cupid had written a curiously ironic script for Wood's love life, however. In her hundred-plus years she fell deeply in love seven times yet did not marry any of these men. She married twice but never made love to either of her husbands. "I do not know if that makes me a good girl gone bad, or a bad girl gone good," Wood reflected late in life.[9]

DUCHAMP AND DADA

*Marcel Duchamp, Francis Picabia, and Wood,
Coney Island, June 21, 1917.*

Beatrice Wood's next love affair, and the most influential in her life, was the result of a duty call to a hospital on September 27, 1916, to visit the recuperating composer Edgard Varèse. She arrived to find Varèse in conversation with a stunningly handsome young Frenchman and was duly introduced to Marcel Duchamp, reigning *enfant terrible* of the art world. "I became aware of a truly extraordinary face," Wood later recalled. "He did not exhibit the hardness of a lifeguard flexing his muscles, but his personality was luminous. He had blue, penetrating eyes and finely chiseled features. Marcel smiled. I smiled. Varèse faded away."[10]

Duchamp was a dashing twenty-nine-year-old who had "the charm of an angel who spoke slang," and he and Beatrice became immediate friends. An intimate relationship developed after she ended her affair with Roché. Wood felt it was natural that they become "as close physically as they were emotionally." Duchamp obliged Wood's need for physical intimacy but, as Wood explained, "you have to understand that Marcel viewed sex as an impersonal act. Intimacy was reserved for friendship." He was indiscriminate in dispensing his sexual favors. The poet Mina Loy, another of his lovers, described him as a "prestidigitator... [who] could insinuate his hand under a woman's bodice and caress her with utter grace."[11] Their relationship gave Wood a quick lesson in the difference between sex and love, and Duchamp's sexual objectivity, far from being an impediment, was actually a relief for Wood. She had not yet fully recovered from her breakup with Roché, and this open relationship allowed for lovemaking "without agonizing ties or the tyranny of heartbreak."

By the time of their meeting Duchamp had already produced a body of work that would secure his formidable place in the history of modern art. He had painted *Nude Descending a Staircase* in 1912 and originated several of his signature "readymades" (assembled from everyday objects), including *Bicycle Wheel* (1913) and *Bottle Rack* (1914). He had also begun his major work, *The Bride Stripped Bare by Her Bachelors Even (The Large Glass)*, 1915–21. Duchamp is now inexorably linked with Dada, the anti-art, anti-war movement that was born in February 1916 in Zürich at the Cabaret Voltaire and attracted such distinctive artists and writers as Tristan Tzara and Jean Arp. The New York Dada group (although it was not known by this name at the time) was by comparison less political and nihilistic than the Zürich-based collective.

Dada transformed twentieth-century art in many ways. The introduction of readymades challenged reverence for skill and craft. Dada's emphasis on language and idea introduced conceptualism to the visual arts. The debate about whether Dada was a constructive or destructive force has continued since. What is not questioned is that, alongside Cubism, it was the most transformative influence on art in the century.

The New York Dada group was led by Duchamp, but its social glue was the patronage of Walter and Louise ("Lou") Arensberg. Their New York apartment functioned as the clubhouse of the emerging Dada group. They were among America's earliest and most adventurous collectors of modern art, and they had discovered the modern movement by attending the groundbreaking Armory Show of 1913 in New York. Afterward, they began to collect, acquiring an impressive number of works by Picasso, Braque, Brancusi, Gleizes, and Duchamp, including *Nude Descending a Staircase No. 2*, which had been shown at the Armory, and which they acquired in 1919.

Duchamp introduced Wood to the Arensbergs; they quickly became friends and remained so for the rest of their lives. Wood was particularly close to Lou, who functioned as a sur-

Mariage d'une amie (*Marriage of a Friend*), 1916, by Wood, published in Rogue *magazine by Duchamp.*

rogate and nonjudgmental mother figure in her life. Wood attended the legendary soirees in their large two-story duplex at 33 West 67th Street, where the recherché Dada group assembled under the leadership of Walter Arensberg, the lawyer and collector Walter Pach, painter Francis Picabia, and Duchamp. The habitués of the Arensbergs' regular rowdy late-night salons included some of the most significant figures in the American and European avant-garde: Mina Loy, Man Ray, Albert Gleizes, Charles Demuth, Charles Sheeler, Joseph Stella, the Stettheimer sisters, and Edgard Varèse.

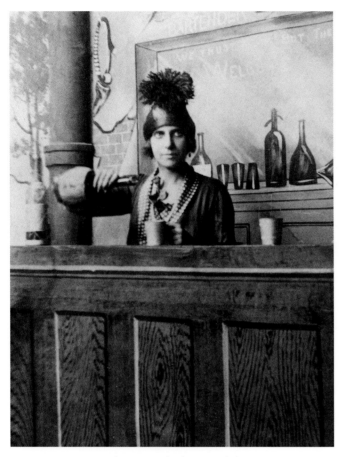

*Wood at Coney Island in a posed photo
as a barmaid, June 21, 1917.*

Arensberg Collection), and by the end of the day she felt that she understood, emotionally if not intellectually, the spirit of this new art. This was a quantum leap for a woman who previously had considered Maxfield Parrish to be the highest standard of beauty in art.

To tease Duchamp, Beatrice announced that anyone could create modern art and promptly drew a "tortured abstraction," entitled *Marriage of a Friend.* Duchamp surprised her. Not only did he like her drawing, he published it in *Rogue,* a small, revolutionary magazine edited by Allen Norton, and then invited her to work in his studio. In the afternoons she would arrive and draw. Duchamp functioned as her editor, brusquely declaring her efforts "good" or "bad" and consigning the unsuccessful drawings without further comment to the trash. They spoke very little about art during their afternoons together. "The great thing between us," Wood recalled, "was the silences . . . they were such easy communication."[12] Duchamp empowered the adventurous but uncertain woman. As she later remarked in an interview, "With Marcel's arm around me I would have gone on any ride into hell with the same heroic abandon as a Japanese lover standing on the rim of a volcano ready to take a suicide leap."[13]

Wood's drawings from this period lack formal skill — the mechanics of perspective always eluded her — but they are spontaneous and magical, imaginatively composed arrangements of sketchy figures (often documenting gatherings of figures from the Dada circle) drawn in a spidery line swathed in mists of translucent watercolors, which give the figures an ethereal, ghostlike appearance. However, she did have some aesthetic ambition, as she revealed in an interview in 1917 when she declared that her goal was to "return to the ecstasy and wild imaginings of childhood."[14]

It was at the Arensbergs' home, confronting their extraordinary collection of paintings and sculpture, that Wood came to terms with the language of modern art, the rawness of which had first repelled her. She spent an entire afternoon focused on an energetic painting by Matisse (now in the Philadelphia Museum of Art together with the rest of the

SALONS AND BALLS

In April 1917 the Society of Independent Artists, founded by a group of artists from the Arensbergs' salon, organized the Independents Salon at Grand Central. The event was modeled on the exhibitions of the French Société des Artistes Indépendants. Anyone who paid dues to the society could exhibit two works without the approval of a jury. The great controversy of this exhibition was the rejection, in contradiction to these egalitarian rules, of a urinal entitled *Fountain,* submitted by Duchamp under the pseudonym R. Mutt. The secondary *succès de scandale* was over one of Wood's submissions, a painting of a woman in her bath with an actual bar of shell-shaped soap strategically nailed onto the painting to preserve the figure's modesty. Wood had meant the title to read *Un peu de savon dans l'eau* (A Little Soap in Some Water), but instead she translated it incorrectly as *Un peut* [sic] *d'eau dans du savon* (A Little Water in Some Soap).

Duchamp loved this accidental and libidinous pun and insisted that Wood retain the title. When it became known that this risqué work was by a woman, it ignited a firestorm of publicity. Sensing a liberated and playful spirit, men optimistically left their calling cards tucked into the frame of the painting. Critics were less charmed and most heaped scorn on the work, deriding Wood's painting as "the keynote of the childish whim." Beatrice fully agreed. She was embarrassed by all the attention she was receiving and wished that the critics had reserved their column space for the serious artists in the show.

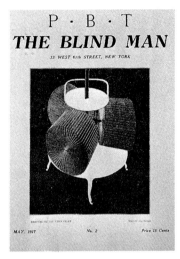

The cover of The Blind Man, *May 1917.*

Together with Roché and Duchamp, Wood published *The Blind Man,* a short-lived avant-garde journal. She also designed the now famous poster for the legendary Dada event the Blindman's Ball, in which a striding stick figure thumbs its nose at the world. The insouciant gesture was meant to annoy Duchamp, who had rejected a more elaborate poster design that Wood preferred. The "Ultra-Bohemian, Pre-Historic, Post-Alcoholic" costume ball was organized by Wood, Duchamp, and Roché as a wake for the magazine's second and final issue. This wild affair, in the tradition of the *Quatre-Arts* balls of the Paris Left Bank, was held at the notorious Webster Hall in Greenwich Village, the so-called Devil's playground for a demimonde of artists, poets, and writers, and the site of transvestite balls by the gay underground.

It was a night of nonstop drinking and shenanigans for the Arensberg circle. Michio Ito, a Japanese dancer, performed and Wood did a Russian folk dance in a heavy, extravagantly brocaded costume. At one point Joseph Stella gallantly offered to fight a duel when someone impugned Wood's honor (alas, already departed), while the professional boxer and writer Arthur Cravan, naked under a sheet, chased poet Mina Loy (dressed as a lampshade) around the dance floor. Although Loy, still recovering from a recent affair with Duchamp, rejected Cravan's advances that night, dismissing him as "a tomb of flesh, devoid of any magnetism,"[15] they fell in love three nights later and were married shortly thereafter in

BLINDMAN'S
BALL

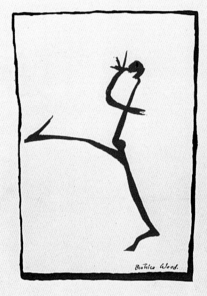

For the BLINDMAN
A Magazine of *Vers Art*

Friday May 25th

at Ultra Bohemian, Pre-
Historic, Post Alcoholic

WEBSTER HALL 119 East 11th Street

DANCING EIGHT-THIRTY

Tickets $1.50 each in advance—$2.00 at the gate. Boxes not
requiring Costume, but requiring Admission tickets $10.00

Everything sold by the BLINDMAN

*Blindman's Ball poster designed
by Wood, 1917.*

RIGHT
*Wood in the costume she wore to the Dada ball
for her Russian folk dances, 1917.*

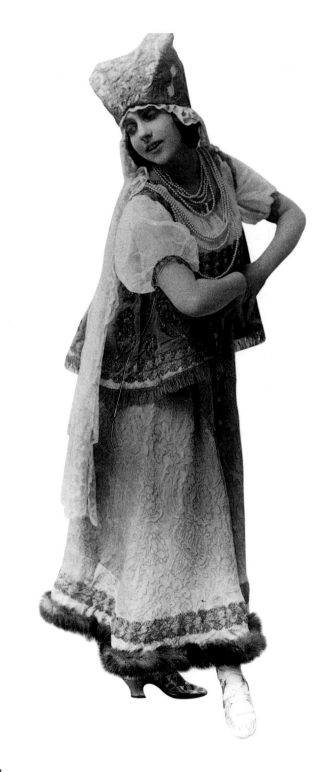

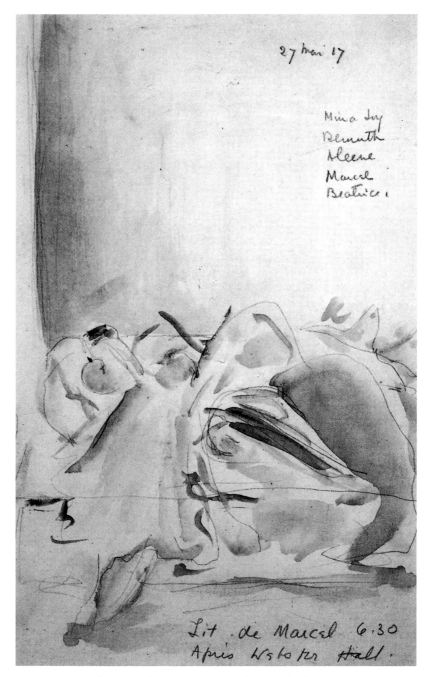

Lit de Marcel (*Marcel's Bed*), 1917. Mina Loy, Charles Demuth,
Aileen Dresser, Beatrice Wood, and Marcel Duchamp in bed.

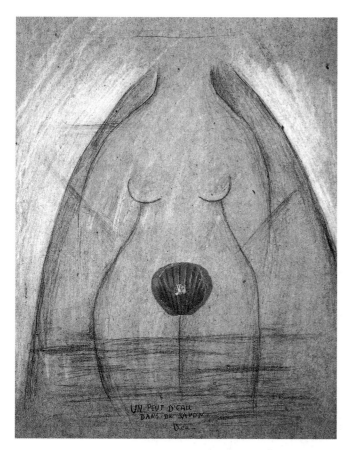

Un peut [*sic*] d'eau dans du savon (*A Little Water in Some Soap*),
1977 replica of 1917 painting.

his pink paper hat to the applause and encouragement of the revelers when he reached the flag.[17]

At 3:00 A.M., the party moved to the Arensbergs' apartment for eggs and wine, and then Wood, Loy, the actress Aileen Dresser, and painter Charles Demuth retired upstairs with Duchamp to his apartment, where they spent the night packed like sardines into his small Murphy bed. Wood squeezed herself into a tiny space between Duchamp and the wall. "I could hear his beating heart. And feel the coolness of his chest," she remembered. Divinely happy, "I never closed my eyes to sleep." A few days later she memorialized the moment in one of her best drawings, *Lit de Marcel* (Marcel's Bed). This idyll would rapidly come to an end, however, interrupted by a move to Montreal that was to have unfortunate consequences.

As much as she enjoyed fellowship with the Dada group, Wood always viewed her place as that of a welcome outsider. "What is really Dada," she confessed at a conference on the Dada movement organized on the occasion of the one hundredth anniversary of Duchamp's birth by the Philadelphia Museum in 1987, "is that I know nothing about Dada," pointing out that she became part of Dada history because of the love of two men. This is true enough, but it allows Wood less credit than she deserves. Certainly she was not a serious artist at this time, and once the group dispersed she merely dabbled in the visual arts until she found her calling in ceramics. Nor did she ever fully come to understand Duchamp's art. Yet for all of this, Wood was suited to this group because she was Dada by nature if not by vocation. Dada provided an outlet for her idiosyncratic spirit and quiet rebellion against conformity.

Mexico. The highlight of the event came late in the night when a dangerously inebriated Duchamp shimmied out, "like a lady bird on a large stalk,"[16] along the second-floor flagpole that jutted out perilously over the dance floor, raising

A FADED MUSSOLINI

In 1918 Wood, ignoring her mother's entreaties, raging ultimatums, and threatened nervous breakdowns, accepted a contract to appear at a theater in Montreal. "My father said I was killing her," Wood wrote with cool detachment, "but seeing as I was the younger, I had the right to live." She left for Montreal with only $15 in her pocket. There she became friends with the theater manager, a Belgian she identified only as Paul, "a heavy-set broad-shouldered man who looked like a faded copy of Mussolini." Feeling lonely, rejected

Wood as "Patricia." A publicity photo as actress at 24 years old.

by her family, and short of cash, she agreed to share an apartment with Paul, but not his bed.

Her mother hired a private detective, discovered and misunderstood the arrangement, suspected the worst, and caused an enormous fuss. She was less concerned with her daughter's happiness than with salvaging Beatrice's honor, this moral property that Beatrice had no interest in defending. Wood, now twenty-five, was being driven to the brink of sanity by her mother's relentless interference. When Paul suggested that marriage would be a release from this maternal chokehold, she foolishly consented. They were married in the New Hampshire home of her friends Beth and Norman Hapgood.

Wood returned to New York in 1920 with her husband in tow and reconnected with the Dada group. But the magic

A languid Wood in her 46th Street apartment, c. 1920.

of the moment had passed. The group had largely dispersed. Roché had returned to France, Duchamp was traveling abroad, and the Arensbergs—whose salon had provided a home for the group—were packing up their collection to move to Los Angeles. By now Wood realized that she had made a tragic mistake, but just how big a mistake was yet to be revealed. The amoral Paul wasted no time in exploiting the affection with which Wood was held in New York, secretly borrowing substantial sums of money from her friends (almost $19,000 from the Arensbergs alone), which he squandered on gambling. Needless to say, Paul never repaid these debts; this left Wood, with her strict ethical values, deeply humiliated.

When they were short of money for food (which was more often than not), Paul would sell a few of Wood's treasured first-edition art books, bought with her allowance while she was at boarding school. He always softened the blow by buying Wood a pound of *marron glacé,* which he knew she adored. Elizabeth Hapgood commented that it was a tribute to Wood's recuperative powers that she "still eats *marron glacé* with zest although at the time [of her marriage] she hated to swallow her beautiful art books in this guise."[18]

Wood remembered this period as one of grinding poverty in a marriage that was a loveless, sexless travesty. For Wood it was the beginning of a lifelong inability to banish strays (human or animal), as she found herself curiously unable to bring this nonrelationship to an end. In 1921 Wood's parents discovered that Paul was legally married to a woman in Belgium and took the initiative. They traveled to Europe, gathered documents to prove Paul's bigamy, and, given that his union with Beatrice had never been consummated, it took the courts "only fifteen minutes to dissolve a marriage that lasted four miserable years."

[5]

PLAYING GOD

Wood emerged liberated from both marriage and mother, and she recovered with commendable speed, promptly falling in love. Reginald Pole was a tall, handsome English actor and director. He was worldly, charming, refined, and irredeemably narcissistic. They met when Pole directed a play in which Wood had a minor role. It was Wood's most bittersweet romance, and though she later lost her heart to other men, she never really stopped loving him. Pole introduced her to a new circle of friends, including

Reginald Pole, c. 1922.

the opera star Lawrence Tibbett, Dr. Annie Besant of the Theosophical Society, and the society's guru, Jiddu Krishnamurti, a man of extraordinary beauty and magnetism. In 1923 Pole directed a passion play in Los Angeles and played Christ (a role with which he "overidentified," in Wood's opinion). Pole invited Wood to visit him in the City of Angels, where she joyfully reconnected with the Arensbergs.

The romance with Pole ended in 1928 when he fell in love with an eighteen-year-old

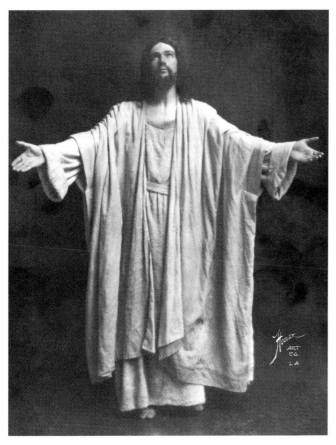

Reginald Pole in the Passion Play as Christ, a role with which Wood contends "he overidentified."

Ojai, a small town surrounded by orange groves and about two hours' drive north of Los Angeles. Wood was at a turning point in her life: disillusioned once again by men and love, confused about her future, without a career, and in need of guidance and spiritual salvation. Krishnamurti's teachings provided her great solace at that moment and for decades to come (until she had a falling out over what she felt was his growing materialism). It was her pursuit of his philosophy that drew her to his retreat in Holland and the discovery of those half dozen luster plates that would transform her life.

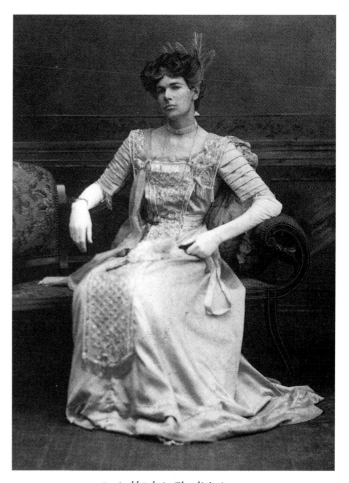

Reginald Pole in Charlie's Aunt.

girl. Wood decided to wipe the slate clean and begin life anew, giving up her Manhattan apartment and moving permanently to Los Angeles. The Arensbergs eased the transition and helped her move to Hollywood. Though it lacked the cultural rigor of New York, Hollywood had a sun-drenched, palm-lined vitality that Wood enjoyed.[19] One of her great pleasures was taking long walks alone in the Hollywood Hills, then largely free of the dense clusters of houses and apartments that today cling perilously to its slopes.

Another reason for her move to Los Angeles was proximity to Krishnamurti, who held regular spiritual "camps" outside

[6]

AFTER HOLLYWOOD HIGH

After three years Wood was unable to find companions for the six baroque, luster dessert plates she had bought in the antiques store in Haarlem, in northern Holland. She eventually decided on a simple solution: she would herself make a matching tea service. After all, how difficult could it be to make one teapot and six cups and saucers? In 1933 she enrolled in a ceramic hobbyists class for adults at Hollywood High School. As it turned out, her goal was nearly impossible given her own lack of knowledge and skills and the technical limitations of the classes at Hollywood High.

Desperate for information about glaze chemistry, she spent many nights reading highly academic papers in the *Bulletins of the Ceramic Society*. She understood hardly a word, but she persevered in the vain hope that "some of this material might enter the subconscious." It did not. Instead, with few peers to turn to for help, she learned painfully by trial and error. At that time California was better known for industrially produced decorative wares, such as the brightly colored vases of the J. A. Bauer Pottery Company and the polychromatic exoticism of the Malibu Tile Company, than it was for the work of the emerging genre that inspired Wood: the independent studio potter.

The studio pottery movement was relatively new. It had begun on the European continent and in England at the turn of the century, although it was not until the 1920s that it started taking on a strong identity, ideology, and momentum. By the 1930s it had begun to take hold in the eastern and midwestern United States, at the College of Clayworking and Ceramics in Alfred, New York; Cranbrook College in Bloomfield Hills, Michigan; an active figurative clay movement in Cleveland, Ohio; and the School of the Art Institute of Chicago. The

The entrance to the Arenbergs' home on Hillside Avenue, Hollywood, c. 1934.

ceramic art community in California was, by comparison, small and undeveloped. West Coast ceramists had yet to discover the potter's wheel. Most studio work was made in a mold or by hand building. Glaze science was largely a matter of luck and empiric experiment; finding even the most common ceramic materials was a trial in itself. It was not until 1938, when the first All-Californian Ceramic Art Exposition was held (with Wood as one of the exhibitors), that the ceramics community began to organize, develop a marketplace, and share expertise.[20]

Undaunted by her lack of knowledge and the field's lack of structure, Wood pressed on in search of financial and technical independence. In 1937, with a friend, Steve Hoag, who had acquired a small property in North Hollywood, she borrowed money and together they built a house. Wood also rented a small shop in the Crossroads of the World, the legendary development of artisan shops on Sunset Boulevard. The rent was only $25 a month with the proviso that she demonstrate her craft to the visiting public, who would watch her glaze and fire her decorated tiles, plates, and molded figures. Moroni Olsen, an actor, underwrote the

rent for six months and Wood launched her business. Results were uneven, both aesthetically and technically, but the work sold (usually for between $2.50 and $5.00) and she made a small profit aided in part by the support of the Welfare Arts Programs of the federal Works Progress Administration. After a year the rent increased beyond her means. She moved into a studio that she had added to her house and began selling wholesale to stores. Wood was equipped to devote her full energy to a career in ceramics when nature staged a dramatic intervention and set back her schedule.

[7]

TAKING A MORTGAGE ON MARRIAGE, AGAIN

Early in February of 1938 it began to rain, and the downpour continued unabated for two weeks. Wood's house survived until the last day of the deluge when, in a final surge, raging waters tore through North Hollywood and consumed her uninsured lot, house, studio, and possessions "in one gulp." The next morning the sun burst forth and "all that was left of my dream house were rows of daisies smilingly open to the sky."[21] Gone, too, were the six luster plates from Holland that had inspired her career. A destitute Wood turned to the Red Cross for disaster relief. Steve convinced her that they would have a better chance if they were married. For the second time in her life, she consented to a platonic marriage (achieved in a five-minute civil ceremony in Las Vegas) and responsibility for another one of life's strays.

Wood's arrangement with Steve, while not intimate, was not without affection, though they were a poor match on many levels and argued incessantly. Steve had no interest in

art and was as conservative as Beatrice was liberal. "I would ask Steve who he was voting for and then without any further research I voted for their opponents, secure in the knowledge that I must be doing the right thing," Wood recalled. Steve was eccentric and given to the unfortunate habit of spouting torrents of pungent profanity at the slightest provocation. Sometimes these outbursts occurred while Wood was in her studio making sales. More than once she covered her embarrassment by airily commenting to her stunned customers, "Good workmen are so hard to find."

The Red Cross support came through. Wood was expecting very little, "perhaps fifteen dollars to replace the glazes," but she received $500 for a new workshop and $225 for a new kiln and materials. Steve received $900 for the lot and they were back in business. The money enabled them to build a better home and studio, but as Wood observed, this came at the cost of another marriage, a "mortgage of my life that was immense."

GLEN LUKENS

Rehoused, Wood turned her attention once again to her ceramics education. The only pottery course of consequence in Los Angeles was taught by Glen Lukens, at the University of Southern California. Lukens had studied ceramics under Myrtle French at the School of the Art Institute of Chicago, and after graduating he established a program for the Surgeon General using pottery as therapy to rehabilitate the wounded of World War I. Then as later, Lukens seemed to see pottery more as a social medium than an aesthetic endeavor. He moved to California in 1924, and after a couple of years of obsession with reproducing the ancient Egyptian blue glazes (an imitative malady that affected all potters in the 1920s), he began his pioneering development of alkaline glazes using simple, unrefined materials gathered from the harsh terrain of the Mohave Desert and Death Valley. Lukens produced a limited but exquisite range of colors and textures that were, in the words of Cleveland ceramist Hugh C. Cowan, "as luscious as ripe fruit." That, combined with simple but powerful molded earthenware forms, soon earned him a national reputation.

According to Wood, she was "the most interested student in the class, and certainly the least gifted." She contended that she was not a born craftsman: "Many with natural talent do not have to struggle, they ride on an easy talent and never soar. But I worked and worked, obsessed with learning." Lukens, a patient and gentle teacher, introduced Wood to a world of craft and form and guided her through a discovery of the millennia-long history of the medium. Lukens's credo was that "the new in art is incredibly old and the old is still vastly new."

Wood got on well with Lukens and often spent weekends visiting with him and his male companion, but he never stirred the artist in Wood. Lukens was perhaps too much of a purist for Wood, whose own tastes ran to rather eccentric decoration and sentimental clown figures. Moreover, Lukens did not encourage individuality among his students. Most of their work looked very much like his. He argued that sublimation to the materials and processes would, over a process of years, lead to an expression of the self. This message of deferred gratification held no fascination for an impatient Wood. Nonetheless, Lukens's restrained approach proved to be the perfect decompression chamber for Wood's unschooled exuberance, priming her to better understand the aesthetics of her fiery art and preparing her for the elegant, inspirational pottery of an Austrian husband and wife team named Gertrud and Otto Natzler.

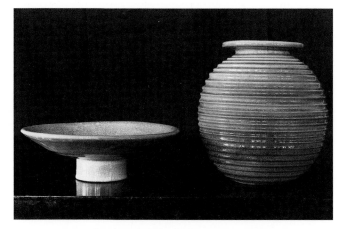

Two pots, loosely in the style of Glen Lukens, made by Wood as part of the WPA arts programs, c. 1937.

THE NATZLERS

The Natzlers set up their first studio together in Vienna in 1935, agreeing to a clear division of labor. Gertrud threw light, classical forms that seemed to float off the wheel; she was the most refined and sensitive thrower of her era. Otto was in charge of the surfaces, creating an extraordinary range of colors and textures: rough "volcanic" glazes, the rich and decadent burnt orange of "tiger's eye" glazes, and a silky midnight blue studded with jewel-like crystalline formations and delicate brushes of silvery iridescence. The Natzlers were soon exhibiting their works in galleries and, in 1937, rose to prominence when they won a silver medal at the Paris International Exposition of Decorative Art. In 1938, with the political climate darkening, they immigrated to the United States, eventually settling in Los Angeles. In 1939 they entered the Ceramic National in Syracuse, New York. This was North America's premier ceramic showcase, and they won first prize, an auspicious launch for their career in this country.

In 1940, having read about their arrival in a brief newspaper report, Wood arranged to meet them, unprepared for the impact their work would have on her. She was stunned and intimidated by the lightness, beauty, and classical refinement of Gertrud's bowls perched on their tiny, immaculately turned feet and by Otto's command of glaze science. She had never seen work of such beauty by any living potter. "Gertrud's bowls touched perfection and Otto's understanding of glazes miraculously merged with her shapes," she remembered. This, finally, was the missing part of the ceramic puzzle that Wood had been seeking. Up to this point, she

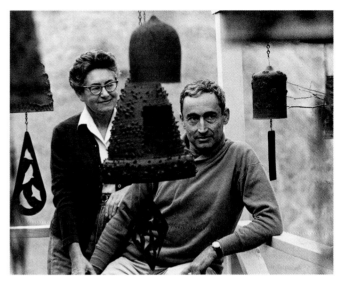

The two most important mentors in Beatrice's career, Gertrud and Otto Natzler.

had been wrestling with the field's more pragmatic priorities, the day-to-day craft of her medium. Now she sensed ceramics' expansive artistic horizons and immediately offered to join the Natzlers as a student.

In some ways the Natzlers were excellent teachers, communicating their seriousness and integrity as artists. They saw pottery as meticulously structured visual poetry. "The form of a pot is its spiritual substance," wrote Otto. "Its outline, its proportions, the finger marks impressed on its wall, are the simple statement of its creator, spontaneous and personal as his handwriting. The same pot does not happen twice." However, unlike American potters who shared their knowl-

edge readily, the Natzlers withheld information about their techniques and glaze "secrets," and this resulted in an ambivalence about teaching. For a time their relationship with Wood blossomed, and Wood treasured this privileged period of "creative companionship" to the end of her life. But as Wood's own following began to grow, the Natzlers grew uneasy, possibly fearing they were nurturing their own competition. They accused her of stealing their glazes and forms and demanded that she leave, causing a painful rift that was never mended.

This break in their association remained one of Wood's enduring sadnesses, and she never fully understood their charges. "I was their student, they taught me to throw and make glazes," she said. "Of course my work resembled theirs!" Even though she remained in awe of their pots and always credited them as the primary inspiration for her aesthetic awakening, she was equally quick to point out that, despite this debt, the glazes she used were all her own, and the language of her pottery was very different from that of the Natzlers.

[10]

TO OJAI

Wood left the tutelage of the Natzlers a changed woman, having lost another kind of innocence. No longer content with just making pots for a living, she was now fired with creative ambition, and craved the rapture of aesthetic ecstasy. Determined to find her own place within the ceramic firmament, Wood increasingly focused on the technique that had first inspired her: luster glazes. Her conflict with the Natzlers, however, was not merely over the petty issue of proprietary glazes. The friction also stemmed from the fact that Wood was fundamentally a different kind of artist than her Austrian teachers. Their pottery aesthetic was based on the most rigid control of clay, kiln, and glaze (no matter how spontaneous and serendipitous some of their surfaces may appear). Wood's free exploration, her love of the unconventional, and her readiness to sacrifice the virtue of classical elegance to gain liveliness were undoubtedly disquieting and a threat to the Natzlers' perfectionist doctrine.

In 1942 she wrote in *Craft Horizons* magazine, "With experience and curiosity, original twists and methods develop.

Anything that one imagines should be tried — within the bounds of [physical] safety. Though disasters and disappointments are met, yet one goes on toward a point of view that is alive, and occasionally good fortune achieves effects never seen before."[22]

After all, Wood had been through the iconoclastic baptism of Dada and desired to speak more informally through her clay and the kiln. "Perfection bores me," Wood said. "I do not want to know exactly what I am going to find when I open the kiln. That would be like living with a man for fifty years whose every remark can be predicted. I would rather be surprised every time the kiln door opens, even though I know that surprise will not always be a pleasant one." Her forms carried a more relaxed and playful line than the Natzlers', and her glazes were more experimental. As a result, her technical achievements were erratic, but the work had life, energy, spontaneity, and, above all, humor. The latter was a quality totally absent from the Natzlers' beautiful, elegant, but self-important and sober bowls and vases.

Interest in Wood's pottery began to grow. She showed work in New York at the Metropolitan Museum of Art (*Contemporary American Industrial Art,* 1940); the Raymond Galleries, Los Angeles (*Four Craftsmen of the Arts,* 1941); a one-person show at American House, New York (*Ceramics of Beatrice Wood,* 1944, for which Marcel Duchamp designed the cover of the exhibition catalog); and a group show at the Los Angeles Museum of Art (*California Guild,* 1947). In addition she was receiving orders for her work from the arts and crafts departments of major department stores, including Marshall Field's, Neiman Marcus, Gump's, and Haggarties. By 1948 her career was sufficiently established for her to feel confident in building a new house of her own in Ojai.

Though she and Steve had agreed that their marriage would be in name only, she felt unable to desert her cranky,

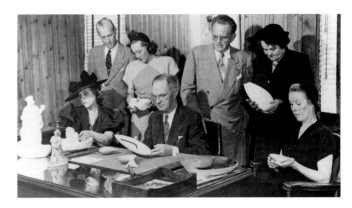

Haeger Awards, Chicago, 1947. Left to right: Beatrice Wood; Joseph F. Estes, vice president and general manager for Royal Haeger Pottery; unknown; Edmund H. Haeger; unknown; Maija Grotell and Marion Lawrence Fosdick, two leading potters and teachers of the day.

foul-mouthed companion, who was now losing his hearing and had become increasingly dependent upon her. After a brief separation, when Wood tried to reclaim her independence, she relented and he rejoined her. They remained together until his death in 1960.

The first few years in Ojai were exciting for Wood. She met the potters Vivika and Otto Heino, who became lifelong friends and helped her to develop her craft, in particular her throwing skills. In addition she taught ceramics for the Happy Valley School of the Theosophical Society. Ojai was a retreat for artists, actors, and those in search of alternative lifestyles, and Wood found the social climate stimulating. She was even invited to a party at which her ultimate heartthrob (at that moment), Errol Flynn, was the guest of honor. Wood's hostess seated her on a sofa next to the actor, but Beatrice was so nervous that a few minutes later she fell asleep on his shoulder. Gallantly Flynn remained seated, providing Wood with a pillow, until nearly half an hour later when she awoke, acutely embarrassed. Sleeping with this movie legend may well have been what Wood had in mind, but not in the way this scenario played out.

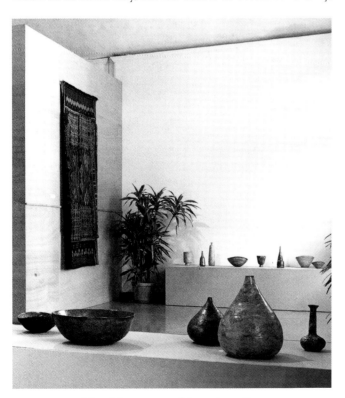

View of the exhibition at Honolulu Academy of Arts, 1952.

Wood teaching at the Happy Valley School, Ojai, c. 1960.

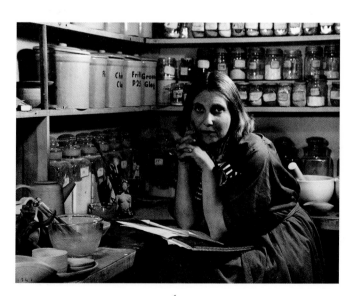

Wood, 1949.

Established in her Ojai home, showroom, and studio, Wood began to create her most mature work to date, using a palette of the glorious luster surfaces that flowed like liquid light over her soft, yielding forms. The work was so unique that no direct comparison can be made within the ceramic tradition. In aesthetic terms the work resembled most closely the exquisite glass antiquities of Egypt, whose lustrous patina was the result of centuries of being buried underground. But her pots are, ultimately, a hybrid of many approaches to the twelve-hundred-year-old history of luster surfaces.

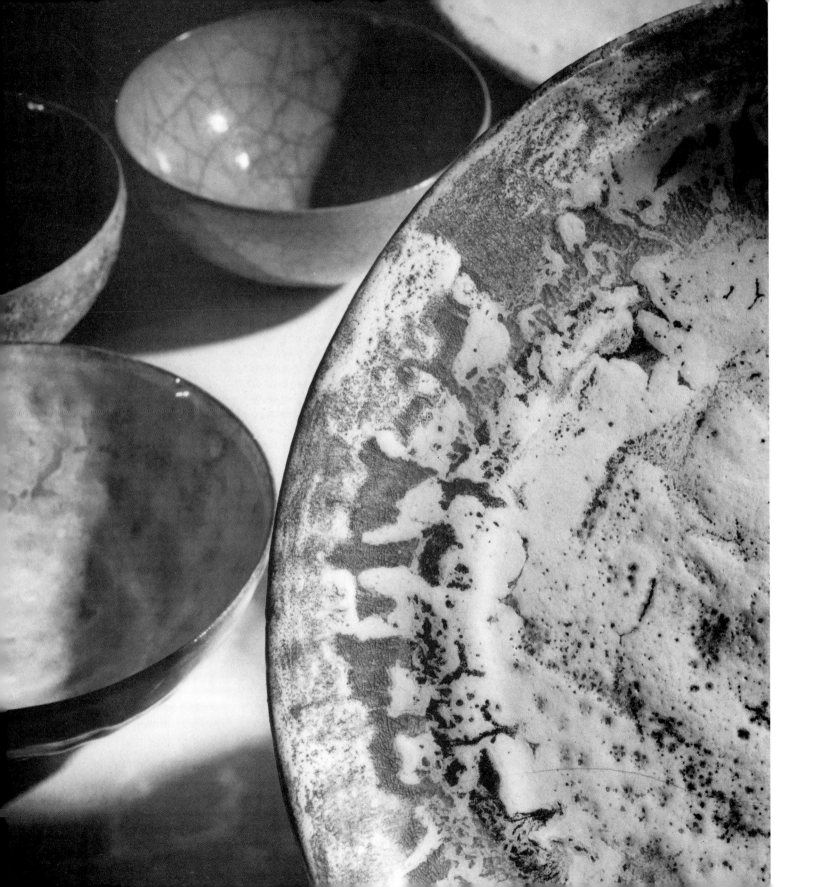

ALL THAT GLITTERS

To place Wood's contribution to this mercurial and difficult art in perspective requires a brief look at the tradition of luster pottery. A luster glaze is a fired, glasslike surface on a clay body; it reflects light waves to produce a diffraction effect caused by the presence of metallic salts on the glaze surface. Luster surfaces are thought to originate from pre-Islamic Egypt, where they first appeared on glass. The most accomplished early luster pottery dates from ninth-century Mesopotamia. These wares were first fired with a tin glaze, then metallic pigments were applied and the ware was fired again at a lower temperature in a reduction atmosphere.

The technique of luster glazing spread from Persia to Egypt and then to Europe through the Moorish conquest of Spain that produced the dramatic Hispano-Moresque wares. By 1800 the potter John Hancock of Hanley in England had perfected a luster technique for mass production using gold or platinum on glaze. This popular production of luster did not add much to the art of the medium. The luster was thinly applied, wore off the glaze surface rather easily, and was visually uninspiring, lacking the richness and idiosyncracies of the earlier reduction lusters.

Luster pottery enjoyed a renaissance in the decadent fin de siècle spirit of the Aesthetic, Arts and Crafts, and Art Nouveau movements. William de Morgan, Clement Massier, Jacques Sicard, and the American ceramist Mary Chase Perry of Pewabic Pottery were among the masters of this art form. The 1920s saw luster used mainly in commercial pro-

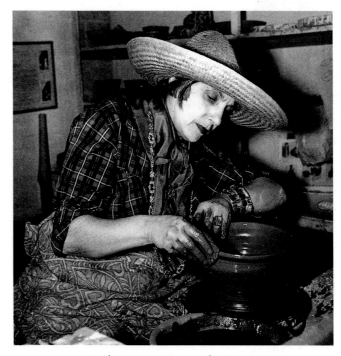

Wood in Mexican peasant garb, Ojai, 1951.

duction, such as Daisy Makeig-Jones's "Fairyland" lusters for Wedgwood and the "Carltonware" of the Wiltshaw and Robinson Works in Stoke on Trent. However, among the studio potters, little work of distinction or originality was produced during this time.

Wood's approach to luster glazed pots represented a new modernist frontier. Luster in modern pottery had become dominated by surface decoration, painting on an already glazed form with low-fire luster overglazes. In her early work, Wood used this "bottle luster," as potters refer to it, to

OPPOSITE
Detail of the glazes on Wood's pots, 1945.

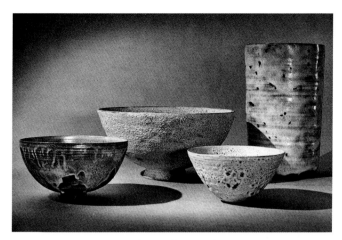

Ceramics by Wood, M. H. de Young
Memorial Museum, 1954.

create on-glaze decoration or drawings on plates and bowls, but she never found it satisfactory. Instead she developed a signature style of glazing, an all-over, in-glaze luster produced during a reduction glaze firing that draws the metallic salts to the surface of the glaze by starving the kiln of oxygen.

Wood accomplished this simply by tossing mothballs into her electric kiln at the appropriate moment. This firing technique creates a stable glaze of distinctive depth, color, and tonal richness. The process is fraught with difficulties. It is elusive and almost impossible to control. Minute shifts in temperature can ruin a surface. Furthermore, the color, texture, and mottling of the glaze cannot easily be replicated, so every new firing presents surprises, disappointments, and challenges. It is partly a game of chance. While it cannot be claimed (as some writers spuriously suggest) that Beatrice introduced in-glaze luster as a technique, she did bring to this lively tradition an artistry, theatricality, modernity, and adventurousness that exceeded anything previously produced.

The results over the years included a stunning range of colors and textures, from complex gold/pink/blue combina-

tions and rich yellow-golds pocked with flecks of matte black, turquoises, and silvers, to viridian and lime greens (similar in some ways to the acidic luminosity of Zolnay and Ampora factory wares from the Austro-Hungarian empire). Her vessels, with their relaxed, rather primal forms, are perfect foils to the bright lava of her flowing glazes, which seem to forgive, neutralize, and at times even revel in Wood's almost casual approach to craft

The essence of Wood's pottery is that she painted form with light. The result is not just a glamorous object but one that is visually alive. As the day progresses, her luster surfaces change color as the light illuminates different color spectrums within the glaze. In the morning a pot will seem predominantly gold; by afternoon it may have picked up a pink or purple cast. This makes living with Wood's pots as unpredictable as her firings.

In 1965 Wood received one of her most perceptive reviews, from the writer Anaïs Nin, written about her one-woman show at the California Palace of the Legion of Honor in San Francisco. The two had become friends through Reginald Pole, whose son, Rupert, was then Nin's companion. Later, writing in the January issue of *Artforum,* Nin instinctively went to the core of Wood's vessel aesthetic:

People sometimes look wistfully at pieces of ancient ceramics in museums as if such beauty were part of a lost and buried past. But Beatrice Wood is a modern ceramist creating objects today that would enhance your life. The colors, textures and forms are at once vivid and subtle. The decorative ability is extended into portrayals of humor, euphoria, or contemplation. Her colors are molded with light. Some have tiny craters, as if formed by the evolutions, contractions and expansions of the earth itself. Some seem made of shells or pearls, others are iridescent and smoky like trailways left by satellites. [23]

[12]

MAKING FIGURES

By the end of the 1950s, Wood's reputation as an artist was well established and was now becoming based primarily upon her luster vessels, which now dominated her ceramic production. Yet she never stopped making figures, and though they are not the primary focus of this book, Wood's figurative pieces remained an important part of her output and are certainly her most personal work. These humorous tableaux provided her with a ceramic soapbox that gave both form and voice to her values, politics, and philosophies. But she did not see the work as serious sculpture. "Good God, no!" she answered Francis M. Naumann on this question. "I just make little figures. I'm not even a craftsman. I am an artist, which has saved me."[24]

Figures were an important part of her output during the 1930s and early '40s. She made small, whimsical figures of clowns, portraits of the Duchess of Windsor (before and after her marriage), dancing ladies, and lovesick maidens, among other subjects. She also made portraits of friends like Helen Freeman, and autobiographical pieces such as a series of figures illustrating her marriage to Steve. Around 1943, when Wood was involved with Art in Action—a group of fifty craftspeople who exhibited their wares in booths on the corner of Third Street and Fairfax (now the site of the Farmers Market)—she tried to expand her production by molding

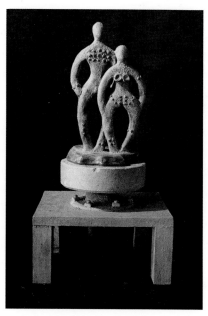

An early figure by Wood, c. 1935.

figures in quantity. Unable to find staff who could reproduce the forms, she returned to making her pieces by hand.

Even as Wood's skills increased, she consciously retained her naive, illustrative style to communicate her commentaries on life and love. In the hands of another artist this style may have seemed contrived and mawkish, that deadly pseudo-primitiveness that the French rightly deride as *faux naïf*. But with Wood, the result was charming—in part because she was one of those rare individuals who managed to keep a childlike innocence alive and untouched within what was otherwise a woman of considerable sophistication. This, combined with Wood's genuine fascination with all types of non-Western folk and primitive art, her sly wit, and her love of deadpan Dadaesque tongue-in-cheek provocation, lent her figures eloquence, integrity, and, at times, a biting irony.

Although her early figures were decorative, Wood gradually began to explore themes that had long intrigued the amateur psychologist within herself—the relationships between men and women and the fierce battleground of sexuality on which their games are played. As Francis M. Naumann wrote in *Intimate Appeal: The Figurative Art of Beatrice Wood* (the catalog of the traveling exhibition organized by the Oakland Museum in 1990), Wood's figures beginning in 1940 became increasingly "generic," no longer specific people or personalities but

"tokens of sexual identity"[25] for everyman and everywoman. Naumann cites the example of one of Wood's most famous and controversial figures, entitled *Settling the Middle East Question* (1958), in which a fully clothed man and woman, cloaked in a dark green crater glaze, lie in a tight embrace. "The rigidity of their bodies," Naumann observed, "preserves the tension in their relationship, while the superior position of the woman suggests that her partner has for the moment renounced his advantage of greater physical power. The title, of course, emphasizes the impermanence of any 'settlement' of the lovers' difference and at the same time reminds us of how complicated those differences are."[26]

In 1970 Wood began to bring prostitutes and bordellos into her figurative realm. Wood's intrigue with this demi-monde is long-standing. In her autobiography, she recalls an incident when she visited Coney Island one evening in 1917 with Marcel Duchamp and the French artist Francis Picabia. As they walked down the boardwalk together, a policeman, seeing a woman out at night with two men, assumed that she was a streetwalker and attempted to arrest her for soliciting. This infuriated the hotheaded, chivalrous Picabia, who came nearly to blows with the officer, but Wood, far from being insulted, was excited at being mistaken for a "wicked woman," and this incident "crowned a dreamy evening"[27] of wild roller-coaster rides with Duchamp. That Wood took this as a compliment of sorts is revealing, a reaction to the stifling respectability of her childhood, a nod to her nonconformist spirit, but perhaps most important an expression of Wood's nonjudgmental, compassionate acceptance of the human condition.

Wood saw prostitution through the eyes of an idealist, as a metaphor for a bargaining table where man and woman can play out their sexual differences, establish gender protocols, and agree to erotic truces outside the moralizing strictures of marriage. Critics may point out that this view ignores the grim realities of prostitution, but Wood was an artist, not a documentarian. Her truths were embedded not in stark reality but in her romantic vision. As Jody Clowes wrote regarding a 1995 exhibition of Wood's work at Perimeter Gallery, "These figures inhabit a fairytale from the past in which only 'loose' women were supposed to express or even notice their sexuality...Wood's frisky prostitutes are joyfully unreal, safely nestled in pink curtains and brothel walls; their clothed top-hatted johns are charming and non-threatening."[28]

Her figures and wall panels depicting prostitutes and bordellos can best be described, as Wood did, as "naughty." They are edgy but never truly immoral or prurient. In *Good Morning America* (1988), the front of the work depicts a bordello with girls exhibiting their wares in large picture windows. This vista of immorality is contrasted at the back of the piece, which lists the respectable professions of the "johns"— Lawyer, Editor, Major, Teacher — represented by happy, dancing stick figures, gently prodding the bias of sexual politics in which the women are seen as whores while the men are viewed more neutrally as customers.

Not all the artist's sexual issues deal with ladies of the evening. *Innocence Is Not Enough* (1959) features a tiny, trusting girl seated on the lap of a man who looms over her with Machiavellian bulk and presence. This is one of Wood's most effective pieces, and its ambiguity projects a chilling mood. Is the man the protector or the abuser? Wood's title leaves the viewer free to make his or her own judgment about this unsettling piece, but it does tilt the work slightly to the darker side.

INDIA AND SHIBUI

In 1961 a chance visit to Wood's studio by Chatopaday Kamaladevi, the president of the Handicrafts Board of India, resulted in one of Wood's most rewarding romances: with the culture of India. Kamaladevi was stunned by the quality and power of Wood's ceramic work, declaring it the "most beautiful pottery" she had ever seen. As a result of Kamaladevi's enthusiasm and adroit lobbying, Wood received an invitation from the American State Department to visit India and show her work on a fourteen-city tour. The visit was an enormous success. It also cured Wood of her fear of public speaking. At each new venue she was expected to make a speech, and by the end of the trip she had metamorphosed from a shy, tongue-tied Westerner into an engagingly witty speaker and an impassioned defender of democracy. Wood returned to India a second time, in 1965, at the invitation of the Indian government, and in 1972 she made a third visit "at the invitation of Beatrice Wood."

These events impacted on Wood's life in many ways. She fell in love with India and, inevitably but briefly, with one of its more handsome citizens. She deeply respected the country's craft genius and collected its folk arts, filling her home with Indian wood and clay figures, metal vessels, and textiles. She also adopted the sari and layers of silver jewelry as her style of daily dress. It was during her second visit that she struck up a close friendship with an Indian man, Ram Pravesh Singh, who worked for the State Department. Singh later joined Wood in Ojai as her manager and remained in this post for twenty-five years, until 1994.

India did little to change Wood's vision of art, since she was already working within the shimmering mirrored, silver-

and gold-threaded palette of the Indian decorative arts. But she did take home some influences. Her work became more lively, particularly in its surface treatment, which was inspired by the relief surfaces on the silver jewelry she now collected and wore. Unquestionably, the Indian tradition of erotic terra-cotta relief sculpture had an impact on her tile panels, in both style and content. All told, her visits to India reinforced an aesthetic of glamour and glitter that she had long followed and brought her playful sexuality more to the fore.

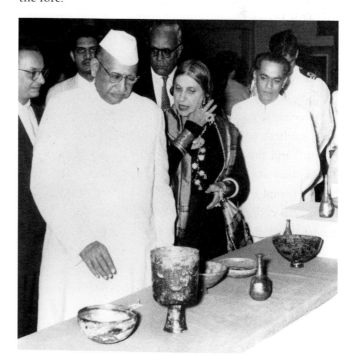

Wood with Sri Prakasa, governor of Bombay, at the opening of her exhibition in India, 1965.

*Wood at her exhibition of pottery, Takashimaya
department store, Tokyo, 1961.*

Her first trip also coincided with a small exhibition at the prestigious Takashimaya department store in Tokyo, and she squeezed a visit to the city into her itinerary en route to India. The work was enthusiastically received by the Japanese critics, one of whom commented that Japanese potters had a great deal to learn from the spirit in this modest exhibition. "I suppose that they had enough Shibui and were ready for something different," Wood wrote later in her autobiography. The truth of the matter is that, in spirit if not in style, the work was not all that distant from the ceramic tenets of Japan. There was a good deal of Shibui, a Japanese reverence for a rustic modesty in art, in Beatrice's work and it was the familiarity of her spirit as an artist that impressed her audiences, not necessarily her novelty. In *Zen and Japanese Culture,* Daisetz T. Suzuki addressed the particular beauty of Japanese ceramics. His comment reads as though it were tailored to describe the qualities of Wood's own pottery:

Evidently beauty does not necessarily spell perfection of form. This has been one of the favorite tricks of Japanese artists — to embody beauty in the form of imperfection or even ugliness. When this beauty of imperfection is accompanied by antiquity or primitive uncouthness, we have a glimpse of *sabi,* so prized by Japanese connoisseurs. Antiquity and primitiveness may not be an actuality. If an object of art suggests even superficially the feeling of an historical period, there is *sabi* in it. *Sabi* consists in a rustic unpretentious or archaic imperfection, apparent simplicity of effortlessness in execution, and richness in historical associations; and lastly it contains inexplicable elements that raise the object in question to the rank of artistic production.[29]

Wood's bold shapes, rusticity of form, and the varying textures and thickness of glaze are much in keeping with the basic ideas in Japanese tea wares. However, she approached this style from a distinctly Western point of view and there is precedent upon which to draw. In 1913 the distinguished art historian Roger Fry opened the Omega Workshop in London. He took it upon himself to become a Workshop potter and encouraged other members of the Bloomsbury group to join him in the endeavor.

Like Wood, Fry was a passionate admirer of the so-called primitive arts and argued that technical skill could not guarantee beauty and that aesthetic power could flow only out of a "joy in the making."[30] In the best work of Fry, Duncan Grant, Vanessa Bell, and others at Omega, one sees a certain craft-blind communion with Wood's aesthetic. Although Wood's work is far superior in technical terms, the Omega pots have the same innocent playfulness, wobbly acknowledgment of human vulnerability, and irreverent disregard for the imperatives of perfectionism.

[14]

HAPPY VALLEY

In 1974 Wood moved from Ojai to a new home outside of town, situated on the grounds of the Happy Valley Foundation, a school of the Theosophical Society founded by Krishnamurti, Annie Besant, and Aldous Huxley. The construction of the house was partly financed by the sale of a Duchamp painting that the artist had given to Beatrice as a gift. She was allowed to build the house with the understanding that it would pass to the foundation after her death. Although the members certainly have no regrets, one can be sure that the foundation did not expect the eighty-one-year-old tenant to still be in residence some twenty-four years later.

The building stands alone on a promontory, overlooking a valley that runs the length of a majestic mountain. Wood decided in her later years to take the mountain as her husband, explaining that it was the only partner that she could trust "to be there when I go to bed at night and still be there when I wake up the next morning." A spacious and meticulously organized studio adjoined the house, surrounded by a rambling desert garden of cacti and hardy Southern California flora.

This beautiful environment became a second home for me. I enjoyed arriving a little early and having time to spend on these grounds watching Wood's gardeners at work carefully grooming the plants but maintaining a feeling of natural composition. The single intrusion from the man-made world was the careful scattering of shards and seconds from Beatrice's kiln, which were buried throughout the garden, protruding here and there like a semiunearthed archaeological dig from a culture too exotic to imagine. I did note that Beatrice had an eye for extremely handsome gardeners, whose skimpy clothing and exposed, muscled bodies glistening in the hot Ojai sun did not displease her at all.

Sometimes when she was taking a nap I would retire to the patio that adjoined the dining room and sit in one of the extravagantly large turquoise blue chaises she had designed, communing with the still, impressive mountain as the setting sun began to fleck it with gold. Once she joined me and changed the mood with a characteristic moment of humor. "That mountain is a very important barrier," she said, and I expected her to follow up with something profound. Instead she added, "It is what separates us from Ronald Reagan's ranch," which was located just the other side of the range.

One of the great privileges of friendship with Wood was lunching with her (and whomever happened to be visiting that day) in a dining room filled with her pots and Indian folk art figures and masks. The glass walls of the room looked out on one side onto a protected patio with wooden outdoor furniture painted bright pink and blue and tentlike cloth umbrellas of Wood's own design. A team of dogs usually gamboled on the patio; some were visitors from nearby homes and others belonged to Wood. Providing a home for stray pets was a source of ongoing tension between Singh and Wood. She complained that he "believes dogs and cats are merely animals, whereas I know they are really people."[31]

The batik-draped table was always set regally with a breathtaking array of Wood's functional pottery—giant golden platters, fish-shaped plates in turquoise and cerise, shimmering blue-green water goblets, kingfisher-blue coffee cups, and, for the most important course of all, decorated copper luster dessert bowls. The food was strictly vegetarian (Wood stopped eating meat at the age of nineteen), with a creative mix dominated by Indian and Mexican cuisines. Dessert always included chocolate in one form or another. When Wood issued her invitations she always warned that lunch would be poorly cooked and terrible; needless to say, it was invariably a sumptuous feast.

Wood was an expert hostess, keeping conversation moving with the skill of a seasoned raconteur. On those occasions when it threatened to become boring chatter, she was not above dropping a comment or two of such provocation— either in the startling introduction of street language or in a challenging choice of subject—that the mixture of shock and delight propelled the conversation back to life. Sex, love, and politics were usually the subjects of choice. As a dyed-in-the-wool liberal Democrat, Wood's drift of political debate was predictable, but on other subjects she took surprising positions. We once brought a feminist writer to meet her. The writer, who idolized Wood, was left speechless by Wood's pronouncement that the role of women is to "kiss the feet of men." A similar incident with the actress Bette Midler ended with Midler storming out in rage over a sculpture entitled *The Superior Masculine Mind,* which portrayed a man with a large head. Of course, when one got to know Wood well, one soon realized that she enjoyed playing Dada games. Yes, Wood was forever the ingénue, believing in an idyllic Maxfield Parrish union of man and woman. In her life she was anything but a supplicant, however, and the man for whom she would prostrate herself in this manner had yet to be born.

SELLING POTS

Wood loathed selling her pots. But for years her livelihood depended upon sales from the studio, and while temperamentally ill-suited to the role she learned to be a saleswoman. Visitors to Wood's pottery were greeted in the driveway by a sign that forewarned "Fine pottery, reasonable and unreasonable." Simpler works were priced at anything from $10 to $60 apiece, but Wood obstinately held out for higher prices on what she believed to be the most special of her works. Even in the 1960s Wood was occasionally able to get as much as $2,000 for the best of her tea services, prices that were unheard-of at the time. Despite these intermittent windfalls the pottery barely survived, and paying the bills was a seemingly endless battle.

Her pottery attracted all kinds of clients, from modest collectors to celebrities. The egalitarian Wood treated all to the same mix of charm and bluntness. On one occasion she sold a small dinner service to an elegant visitor who turned out to be Nelson Rockefeller. "When you and your friends wash these dishes," Wood instructed, "be very careful because they are brittle and chip easily." Rockefeller replied with patrician disdain that he and his friends did not wash dishes. "Now that you own my plates, you will," replied a smiling but unperturbed Wood. On another occasion a woman arrived at her studio in a large, expensive car, dripping diamonds. She fell in love with a bowl but balked at the price, stating that she could not afford it. After an hour of haggling and claiming poverty, during which time Wood had budged not one cent on the price, she finally agreed to buy the piece but bemoaned the fact that it meant she would have to "eat crackers for a month." As she was leaving she

Fine pottery, reasonable and unreasonable, 1956.

asked for a glass of water, which Wood brought to her on a plate together with a single cracker "to start you on your way."[32]

As Wood's fame continued to grow she was invited to exhibit her work at more and more museums. She still sold mainly through craft shops and department stores, in particular Gump's, a longtime supporter of her work, but she wanted to simplify the selling of her work. In 1970 she heard about the Zachary Waller Gallery on La Cienega Boulevard in Los Angeles and approached its partners, George Zachary and John Waller, who happily took her into their stable of artists. A good working relationship developed, resulting in one of Wood's most famous exhibitions, *Service for Twelve* (1972–73). This 133-piece service was so costly that both

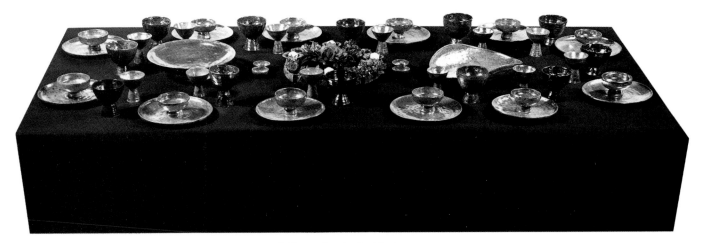

Wood's famous Service for Twelve, *1972–73.*

Wood and her dealers agreed that short of a profligate maharaja on a buying spree, it was unsalable. Instead, they advertised the exhibition and charged an admission fee to see the shimmering table of gold, emerald, and pink lusters. No maharaja materialized, but the exhibition itself was a popular success and every day lines of viewers extended down the block in front of the gallery. Under the guidance of the gallery her career picked up steam, and in 1973 she had her first retrospective exhibition, at the Phoenix Art Museum, accompanied by a modest catalog.

Waller closed the gallery in 1980 and went into private dealing. Wood's sales, which had already begun to decline, dropped precipitously; they reached their nadir in 1981. Nothing sold for nearly two years. Wood became uncharacteristically depressed, convinced that her career was over and that her contribution to ceramic art was not only forgotten but worthless. Little did she suspect that, at the age of eighty-eight, she was poised to enter a new phase of her career, so productive and rewarding that it would eclipse her preceding forty years as a potter.

RENAISSANCE WOMAN

My partner, Mark Del Vecchio, and I were frequent visitors to Wood's home at this low point in her life. I had first met and begun a friendship with Wood in 1978 when working with Margie Hughto on the exhibition and book *A Century of Ceramics in the United States: 1878–1978*. In 1980 I was back at work on another book, *American Potters: The Work of Twenty Modern Masters*, in which Wood was one of the featured artists. On one visit, concerned about her despondency over the lack of sales, we offered to take some of her pots home with us and sell them privately. This had a defining impact on all of our lives. Mark and I quickly discovered that we did not enjoy the intrusion of selling from our Hollywood apartment. Soon after, while out driving, I spotted a space for rent across the street from the Los Angeles County Museum of Art on Wilshire Boulevard. With modest remodeling, we realized, it would make a perfect gallery for ceramics—just what we needed to show off Wood's pots. In a matter of two months, working almost entirely on instinct, with no stable of artists in mind and no planned schedule, we signed a lease. Two friends, Ed Judd and Allen Harriman, put up seed money, and in September 1981 the Garth Clark Gallery opened its premiere exhibition, *Beatrice Wood: A Very Private View.*

The show was an unqualified success; the packed opening-night reception brought out Los Angeles's most active art collectors. It was an unforgettable spectacle, featuring more than forty pieces: a shimmering sea of luster bowls, bottles, vases, goblets, chalices, teapots, and plates in lustrous pinks, golds, turquoises, and greens as well as works in the lesser known black, bright blue, and yellow dry matte glazes that Wood also favored. Sales were excellent, and Wood was back in business. For Mark and me, the change in our lives was dramatic. Seemingly overnight we had become art dealers. Prior to this I was a freelance art historian and critic, and Mark had managed a small distributor of educational materials. It was a shift of focus that neither of us has regretted.

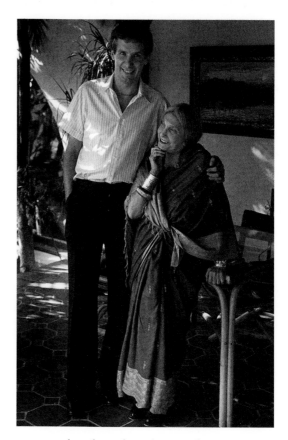

The author with Wood, Los Angeles, 1981.

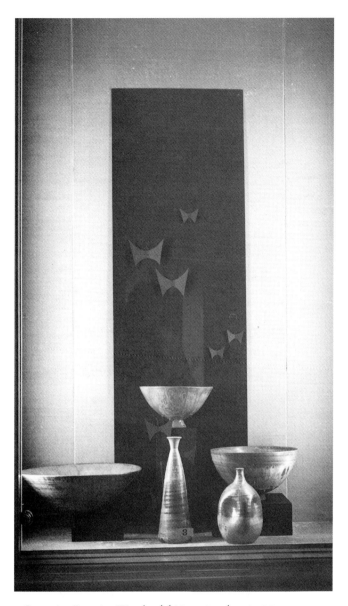

Ceramics: Beatrice Wood, *exhibition at Pasadena Art Museum, 1959.*

Wood with potter Peter Voulkos (left) and friends, 1969.

*Wood with Margie Hughto at her solo exhibition, Everson
Museum of Art, Syracuse, New York, January 1978.*

Wood's first show was easy to organize, as we simply selected pieces from a large number of existing works in her showroom. For the second exhibition, in 1982, Wood wanted to make all new work. I was a little concerned about how to handle this octogenarian artist. Often it takes considerable pressure and toughness to get an artist to produce a show. Just how much pressure could one put on an artist of this age? As the deadline approached, Wood began to grumble more frequently about ungrateful kilns and ill-mannered materials. Listening to her woes during one particular call I assumed that the pressures of the show had become overwhelming, so I offered to create the exhibition out of existing stock, saying that she "need not worry about making new work." There was a brief pause at the other end of the line and then Wood said, quietly but emphatically, "Do not ever say that to me again."

The message was clear. From that time forward we set a schedule of at least two exhibitions a year, sometimes three, once we opened our second gallery, on 57th Street in New York City, and a third, appointment-only gallery in Kansas City. Wood responded to the challenge and the pressures, meeting every single commitment, usually delivering work two to three months early and making many more pieces than she had promised. We soon realized that we were representing an eighty-four-year-old dynamo and that *we* needed to rise to the challenge.

[17]

NEW WORK FOR THE LOCUSTS

The rediscovery of Wood's work brought with it considerable activity. Articles and interviews began to appear in numerous periodicals and museums clamored for her work as she turned ninety and then sailed on toward her centenary. In addition to two or three annual one-woman shows for our galleries, we also included her in group shows when we had enough work on hand, and we organized one-person shows at other galleries in Detroit, St. Louis, London, and elsewhere. We placed her work in major traveling museum exhibitions both in the United States and abroad and in 1983 initiated a large retrospective survey of her work curated by Dextra Frankel at the Art Galleries of California State University, Fullerton. This exhibit toured the United States, ending with a two-part, two-month showing in our New York City space.

Wood responded to the grueling schedule with relish, producing kilnloads of new work. The work was new in more than just the chronological sense and was aesthetically different from her earlier oeuvre in many ways. The glazes were softer and more monochrome than the complex, layered, intense palette that had distinguished her earlier work. But the greatest shift was in the forms. After years of approaching the vessel with some restraint and her own kind of primitivist minimalism, Wood decided to give over to total play. There was an explosion of innovative ideas.

This found expression in sculptural additions to the vessel form: exaggerated and multiple handles, elaborate lids, chains of nude figures surrounding the wall of the pot, elongated spouts, beaded surfaces, and a particularly eccentric group of pots with gold-lustered knobby protuberances

against a green glaze that we at the gallery irreverently christened the "pimple" pots. Wood also sought to merge figurative sculpture with the vessel form. She had done this before, but now this union was more ambitious, resulting in all kinds of charming curiosities, the most successful of which were her pairings of husband and wife teapots. Hilariously upright and uptight, they were the parental guardian figures of a bourgeois morality she had rejected and yet secretly still craved.

For nearly seventeen years we followed a routine of visiting Wood in her studio after each major firing. The ritual was always the same. We arrived late in the morning and took a look at the new work while Wood, seated regally on her large corner sofa, dismissed it all as "terrible" except for a gem or two that she would admit had some small redeeming grace. Then we would enjoy a luncheon of Indian delicacies in the elaborately set dining room and gossip about politics, art, and sex. After dessert we settled down to the serious business of selecting those works that were of the quality we wanted for the gallery. The cost of Wood's surrender to constant experiment was that not all of her innovations were successful. The kiln gave back a mix of gems, ho-hums, and unqualified disasters. The criteria employed in the selection process are not easy to explain. After handling literally thousands of her works, selection became more intuitive than cognitive. Some pieces were rejected for poor form or poor craft; others because the glaze had not been successful or did not complement the host form. In other cases the proportions did not work; a foot was too heavy or a lip too weak.

Wood found this selection process intriguing and confessed that she had never had the ability to judge her own work. At one of these sessions I was waxing eloquent over some pots that had come through the kiln superbly. Wood interrupted me: "If those pots are so successful then I have nothing to learn from them. Tell me about those—" She pointed to the sad group of rejected pots that had been set aside. Wood had remarkably little ego when discussing her work and enjoyed a tough critique, using whatever she learned to advance her art.

At the end of the visit a receipt would be prepared, the luster pots would be waterproofed with a noxious, foul-smelling liquid (Wood always wanted her pieces to be functional and not leak water when holding flowers), retail prices agreed upon, and the car loaded up with its fabulous cargo. Wood would beam with pride and pleasure if the kiln had been kind and we were taking back a particularly large number of pots. If we left with too few pieces, she would be both disappointed and apologetic, heading back to the studio with resolve to make more and better work for our next visit.

Part of the protocol of a visit required feigned distress at being deprived of her treasures by her "locusts," as she referred to Mark and me. Soon we were joined by Locust Number Three, Wayne Kuwada, who directed the Los Angeles gallery until its closure in 1995, and then continued to handle Wood's pottery, working with the Frank Lloyd Gallery that succeeded us. Kuwada had been a fan of Wood's pottery as a teenager, and working with her was a dream come true. In the process he became one of Wood's closest and most adored friends. Wood constantly threatened to elope to Paris with Wayne, a trip they never were able to take in reality although they did so many times over in playful fantasy.

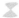

FROM POTS TO PLOTS

Wood's career as a potter and sculptor reborn in her late eighties and exhibiting actively and internationally thereafter for nearly two decades is, in and of itself, an inspirational tale of creative determination. Yet that was only part of Wood's creative output. In the early 1980s she also turned with gusto to writing and publishing. Interestingly, she followed something of a tradition. In 1906 William de Morgan, an intimate of William Morris and one of the greatest of the fin de siècle lusterware potters, published his first novel, announcing that he was moving from "pots to plots." Although she never gave up pottery, Wood's career from 1981 on followed a similar trajectory.

Writing had long been an interest for Wood. From the age of fifteen she had religiously kept a three-line diary, as well as journals of her travels. She also wrote for the Dada publication *The Blind Man* and corresponded with many friends over the years. But the demands of sustaining her pottery business had pushed her ambition to publish some of her literary work to the background. Simply put, she did not feel she could afford the time to indulge this interest.

After her second exhibition at the Garth Clark Gallery, in 1982, she called to let me know that she had the first surplus in her bank account in living memory (a substantial yardstick in her case) and that she would celebrate the occasion by buying herself a tango-dancing Argentinean gigolo. Ultimately, she settled for a vacuum cleaner, which she rightly argued would be "more dependable" if less glam-

orous, and besides, it was urgently needed to keep the intrusive fine Ojai dust out of her home.

With this newfound sense of financial security, Wood now felt the freedom to give attention to her writings. She dusted off her old manuscripts, edited and rewrote them, and started new projects. In 1982 Rogue Press published her first book, *The Angel Who Wore Black Tights,* a modest volume drawn from her journals of her trip with Elizabeth Hapgood to attend Krishnamurti's 1930 camp in Holland and their subsequent trip to Paris. She juxtaposes observations of amusing daily events against brief quotations of Krishnamurti's sage and universal teachings. The book ends with Krishnamurti noting that "Man's greatness is that no one can save him, that is the greatness of man, it is the glory of man.... You want to be saved, you want to worship at altars made by human hands, you want to worship gods created by life, and that is why I say: worship that life which is free, unlimited, unconditioned and absolute. For that is the truth." Looking back over the long years of Wood's life since she recorded his opinion, it is apparent that she took these words to heart.

Her autobiography, *I Shock Myself,* was published in 1985 with the assistance of a fellow potter, Rick Dillingham, under the imprint Dillingham Press. Chronicle Books of San Francisco reprinted the volume in 1988 and it has been in print ever since. This was followed by *Pinching Spaniards,* published in 1988 by Topa Topa, comprising a series of letters that

Wood wrote to Steve Hoag from June to September 1958 while she was on a trip to visit her beloved Roché in Europe. In 1992 *33rd Wife of a Maharajah: A Love Affair in India* was published in Bombay by Allied Publishers. Her third "travel" book, documenting her responses to India and its culture, this is the least known of Wood's books because it was not distributed in the United States, but it is, next to her autobiography, her best piece of writing—lucid, insightful, tinged with sexual frisson, self-effacing, and at times wickedly funny.

The success of Wood's autobiography encouraged Chronicle Books to publish a small book of photographs, *Playing Chess with the Heart* (1993), by Wood's friend Marlene Wallace. Each photograph of Wood is accompanied by one of Wood's sayings, among which one of the most memorable is the Mae Westian epigram "Celibacy is exhausting," accompanied by a photograph of a ninety-nine-year-old Wood draped across a settee with the abandon of a courtesan.

In the same year Wood's play, *Torch in the Sky,* which she wrote in 1927 about Giordano Bruno, a Renaissance monk and philosopher who was burned at the stake for heresy, was given its world premiere by the Helicon Theatre Company in Ojai. Then she returned to her fascination with prostitutes with two modestly produced illustrated books published under the pseudonym Countess Lola Screwinsky, who, as the name suggests, is the madame of a bordello. The first was published in 1994. The second volume, *Kissed Again: Part of the Bargain* (1995), is an A-to-Z guide to managing one's life and brothel (the one being a metaphor for the other); an advance copy arrived on our desk with the inscription, "To Garth and Mark, I could not remain open without you— Countess Lola."

[19]

HONORS, KUDOS, AND GREAT DADA BALLS

Ninety was the turning point for Wood's celebrity. This birthday was memorable for two events besides the anniversary itself. The first was the Blindman's Ball II, and the second was a telegram from her least favorite man the in the world, Ronald Reagan, then the president of the United States. The telegram was a touch premature. It read, "Congratulations on your 100th Birthday." Francis M. Naumann, proposing a toast at Wood's birthday party, said he hoped that when the liberal-minded Wood did in fact reach her one hundredth year, she would receive her telegram from a Democratic president—a wish that was realized by President Bill Clinton.

The second Blindman's Ball, on Friday, March 4, 1983, was a lively event, perhaps less wild than the original but no less enjoyable. We organized the event as both a birthday party and a fund-raiser for the Amie Karen Treatment Center for Children with Cancer, a choice of beneficiary that greatly pleased Wood. The venue was the Terrace Room, an over-the-top ex-Shriner's auditorium at the Park Plaza Hotel in Los Angeles. The room was a huge, richly ornamented Moorish fantasy, designed in 1928 by Anthony Heinsbergen, a master of exotic, eclectic interiors, renowned for his Art Deco masterpiece, the Pantages Theatre in Hollywood. When Wood arrived at 9:45 P.M. for her grand entrance she

*An ecstatic Wood being carried
into the Blindman's Ball II, Los Angeles.*

*Lily Tomlin as "Salvador Dali Parton" with
Beatrice Wood at the Blindman's Ball II, Los Angeles.*

was delighted to find a squad of handsome leather-clad men, led by the potter Art Nelson, whom we had flown in from San Francisco to be her guard of honor.

Wearing black caps, chains, and silver-studded black leather harnesses and codpieces, they carried a delighted Wood into the ballroom, recumbent on cushions within a huge palanquin draped in lustrous pink and gold cloth. This arrival of the perpetual ingénue, smiling beatifically, brought the capacity crowd of costumed revelers from the arts and entertainment worlds to its feet. Men stood on the tables and tossed roses at her. It was the kind of birthday, Wood later remarked, "that every ninety-year-old woman should have." Lily Tomlin, dressed in a gender-bending costume as "Salvador Dali Parton" (she had recently appeared with Dolly Parton in the film *Nine to Five*), delivered a birthday toast, a witty, art-smart poem to Wood written by Jane Wagner that perfectly tweaked the Dada spirit of the night.

It concluded with the following lines as each table lit candles on individual birthday cakes:

And now:
Take a match
And strike it lightly
Set the candles
Burning brightly

Lift your glass
For the introduction
Of this fabulous creature
Beyond destruction

With her tongue in her cheek
And her thumb in her nose
May she go on
Like Gertrude's rose

Dancers at the Blindman's Ball II, Los Angeles,
performing in costumes designed by Wood.

Honors and awards continued to trickle in as she strode through her nineties, building to a flood of attention as the magic number 100 neared. She received honorary doctorates, gold medals, and citations by feminists, ceramic societies, universities, arts and crafts organizations, and museums, and was even sought out by hospitals to be their guest of honor — a slightly ghoulish endorsement. Wood handled all of this attention with grace, wit, and a four-minute speech. When I asked her why she would speak only for such a short time she replied, "No one has anything to say that is so important that it should take any longer." One talk, given to students and faculty at the art department of Arizona State University in Tempe, surprised her audience. The title was "The Importance of an Invoice" and was a reminder to young, aspiring artists that surviving in the art world takes more than creativity.

In addition to giving time for the making of the film *Special People: Beatrice Wood,* written, produced, and directed by Joel Arks and released in 1990, demands on her time also came from the media, Dada historians, pottery fans, her many friends, and weekly busloads of bored, calorie-starved wealthy visitors

from the spas in Ojai, seeking distraction from their health reg-
imens. Beatrice referred to them as the "old biddies," though
most were half her age. Throughout all of this, she continued
to work. Work was her life and the source of her happiness.
She was most content when in her studio, and despite her lim-
ited time the work kept flowing. In 1988 she wrote to me that
"My fate however, seems never to have been easy, for though
I have more energy, I have more interruptions, so I am not
making as many things as I would like. Though I am ready to
die, my desire to [work] keeps me down here [in my studio],
I will never have enough time, for once an idea is pursued,
another pops up, also since the kiln treats me like a battered
wife, many efforts are full of disappointment."[33]

In particular Wood loved the process of throwing, which
never ceased to thrill her. "There's an intoxication when your
hands are there and the clay comes up," she said. "It beats
almost anything else."[34] Wood liked to throw as thin as possible,
and afterward she did very little trimming so that "the imprint
of the fingers could be felt as a living thing in the pot."[35] She saw
success in throwing as being less the product of pure skill than

as the result of focus and intensity. To illustrate the point, she
recounted the story of a friend who had attended a rehearsal
of a ballet by Nijinsky. The dancer was standing still, merely
raising and stretching his arms, "but so concentrated were
his efforts in these simple movements that there was a pool
of sweat at his feet from his focused energy." The same atten-
tion must be given to every gesture on the wheel, for, as Wood
argued, "genius is the capacity for infinite detail."[36]

Work for shows still arrived a month or two ahead of
schedule. She continued to innovate her forms, which became
increasingly decorative with complex beading and relief work.
The signature pots of this period were the large-scale, com-
plex, highly articulated chalices that she assembled and stacked
from thrown and hand-built forms. Some had multiple han-
dles that served the dual purpose of giving a visual elegance
to the form as well as providing architectural stability during
the firing. The critic John Perreault wrote of her overstated
use of the handle that "there is something just right about
the handles—and a bit sassy, like someone standing with
arms akimbo."[37]

[20]

TURNING 100 AND "32"

In 1992, as Wood neared her hundredth birthday, she
confided to me that she had a new problem in her life: "It
used to be men, now it is time."[38] Wood was coping with
a relentless interest from the media in her art and longevity.
Articles about her were appearing in such diverse magazines
as *House & Garden, Smithsonian,* and *Interview.* She was featured
on MTV and on *Good Morning America* and in a documentary
on aging by ex–Surgeon General C. Everett Koop. One of the

complexities, of Wood's own making, was that she insisted
on keeping an open studio, just as she always had since the
day she'd set up shop in Ojai forty-three years earlier.
Nearly three hundred visitors were turning up every month,
and attempts by Singh and others to limit access to Wood
were forcefully rejected by the artist, who felt that "if they
have made the effort to come and visit me, I must make the
effort to meet them." This cut severely into her studio time.

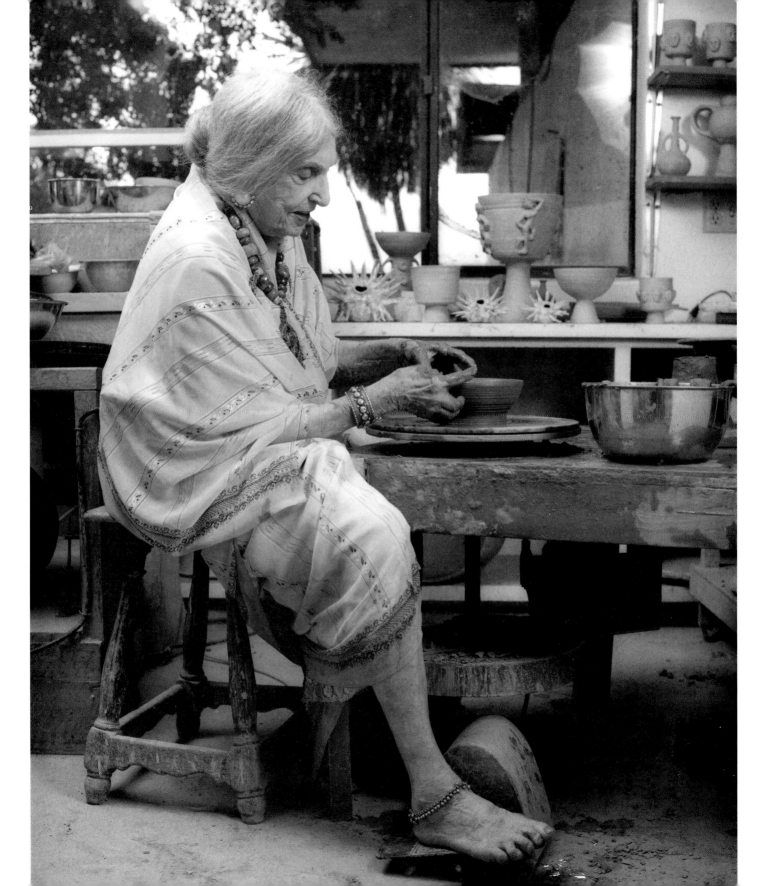

Added to her pressures was the production of a documentary, an ambitious $300,000 film entitled *Beatrice Wood: Mama of Dada.* It was produced by Tom Neff (who also directed the film), Diandra Douglas, and Amie Knox. The film won the 1992 Cine Golden Eagle and has been a staple of the PBS circuit since its release. It was given a full-blown Hollywood premiere at the Los Angeles Design Center on March 3, 1993, with an audience that included Jack Nicholson, Danny DeVito, Leonard Nimoy, and others from the worlds of film and art. They were treated to one of Wood's witty, impromptu, seamless talks about her life (longer than four minutes this time, but the occasion demanded it), and her audience was frequently convulsed with laughter. It was at this event that Wood announced she was bored with her seniority and that from now on she would remain, forever, only thirty-two years old.

On the following Sunday, David VanGilder and Kevin Settles staged a memorable birthday pageant for hundreds of friends and guests at the Happy Valley School. Among Wood's surprises was the arrival of a friend, actress Tippi Hedren, accompanied by a full-grown Siberian tiger from Shambala, Hedren's refuge for wild animals. Wood was told nothing about the arrival of the cat and was asked simply to come out onto the patio. Striding through the dining room door and into the light she saw Tippi and the tiger. Without hesitation, Wood walked over to the large cat and patted its head delightedly.

Throughout all the fuss and hullabaloo over her centenary, Wood kept her objectivity. At a luncheon to celebrate her birthday, we sat eating and talking and perspiring under the hot, bright klieg lights of a *60 Minutes* film crew who were recording the event for a segment about the artist. I asked how she felt about all the attention. Wood replied that she had no delusions about what was happening. "I am getting publicity because I am a freak, a hundred-year-old woman," she commented. "I have no interest in publicity about my life anymore. But I consent to the articles and television for one reason. I am an artist. And if all of this ends up producing a few inches of serious writing about my work, then it is all worthwhile."

The year did produce serious attention for her art. Wood had three simultaneous exhibitions at our three galleries. Roberta Smith wrote admiringly in the *New York Times* that the Manhattan exhibition of twenty-six pieces "confirms her specialty in the somewhat unpredictable [area of] luster glaze, whose iridescent colors are tinged with gold or pink or green, sometimes within the same vessel. These surfaces are spectacular and subtle at the same time: three large platters, two of them made within the year, seem discreetly matte when viewed directly, but from an angle the surfaces suddenly exude a sunset brilliance."[39]

In a review for *Art in America,* Brooks Adams wrote of her chalices and their traditional symbolism, which "carries overtones of some Arthurian and Parsifalian orgy, a kind of syncretic, cup-raised cult of the self. The largish vessels have subtly changing metallic sheens (which sometimes evoke the cosmetic deformations of the African tribal women) and multi-lobed handles. Standing as high as 15 inches they can be relatively restrained in form, with three button shapes in a line down the neck from the principal ornament, or insistently more complex in silhouette, suggesting octopus tendrils and Renaissance glass in their curlicued shapes." Adams ended the piece with the statement that Wood had now earned her place in the "pantheon of great American woman artists."[40]

A NEAR MISS

ood's 101st year began auspiciously enough. She was reasonably productive in the studio, and media interest had slowed down slightly, but she did receive one of her greatest honors when she was named California's Living Treasure at a massive banquet in Los Angeles. This Governor's Awards for the Arts Gala, hosted by the Republican governor of California, Pete Wilson, also conferred honors on director Steven Spielberg, writer Alice Walker, and painter David Hockney. Wood was polite but noticeably cool in the presence of the governor, whose conservative policies and anti-immigrant and anti-gay politics were anathema to her.

A third Blindman's Ball was also in preparation. It had been planned to coincide with Wood's hundredth birthday and a retrospective at the American Craft Museum, but when this exhibition was abruptly canceled we decided to move the event to the following year. The ball benefited two AIDS charities—Visual AIDS (creators of the red ribbon) and Housing Works—a particular passion for Wood, who had lost several close friends to the disease and was a tireless and generous supporter of various AIDS benefits. The fact that the event was for AIDS required a name change to the Dada Ball. Blindness is one of the consequences of the disease, making "Blindman's Ball" a callous title under the circumstances. What made this event particularly exciting was that Mark and I were re-creating it in Webster Hall, the ball's original 1917 venue, which had conveniently been converted into a dance club.

A reveler at the Dada Ball, Webster Hall, 1994.

Wood threw herself into the event. She and David VanGilder made numerous calls and wrote letters to help assemble the benefit committee. Wood invited America's premier painter, Jasper Johns, to be her co-chairperson. Johns, also a Dada aficionado, agreed, confiding to me later, "What option did I have—who could say no when a one-hundred-and-one-year-old woman invites you to go to a ball?" Gearing up for the event, Wood wrote a letter that showed both her enthusiasm for the event and her innocence about drugs: "I'm going to the Doctor for a checkup asking if there was anything like Cocaine or Marijuana that is legal and not injurious that could give more energy so I can dance on the rooftops [at Webster Hall]. In the meanwhile I am working hard up to the strength I have, with you always in the background waving a big stick and saying, 'hurry up, hurry up make something decent for me.'"[41]

Trouble often slips quietly through the door. In Wood's case it began shortly after her birthday in March with a cold, which became bronchitis and then deteriorated step by step to pneumonia, collapsed lungs, and three months wired to machines in the intensive care unit of the Cedars-Sinai Medical Center in Los Angeles. The doctors at the center gave her a 3 percent chance of survival, but David VanGilder and others were at her side every day giving encouragement and support. Eventually she was strong enough to leave intensive care, though too weak to speak. When she finally recovered speech,

Revelers at the Dada Ball, Webster Hall, 1994.

*Mark Del Vecchio, Tippi Hedren (Wood's representative),
and Garth Clark at the Dada Ball, Webster Hall, 1994.*

*Lennie Berkowitz (as Beatrice) and Wayne Kuwada
at the Dada Ball, Webster Hall, 1994.*

the first sentence out of her mouth, a barely audible croak, was "Get me out of here." She was moved to her home and from then on the recovery was dramatic.

Wood's doctors had predicted that she would not be able to walk again and that she certainly would never return to her studio. She proved them wrong in both cases. By March of the next year, she dumbfounded her doctors by producing sixteen extraordinary pots, which we christened the "Miracle" pots. They were modest in scale, a little more funky and informal than usual, and the kiln, perhaps feeling some sympathy for Wood's medical travails, blessed them with some of the best surfaces of her career. These pots have an intensity and glow that, even within her oeuvre, are remarkable.

The ball went on as planned. It caught the imagination of the New York art world, and on October 11 nearly fifteen hundred artists, dancers, actors, collectors, dealers, drag queens, club kids, performance artists, AIDS activists, and bon vivants (mostly in costume) crowded into historic Webster Hall to relive the excitement of the original Blindman's artist ball. Three hundred "greeters," some dressed in drag or in outrageous costume, others covered head-to-toe in tattoos or other body ornament, welcomed the first arrivals. Twelve of New York's best restaurants (from Nobu to Chanterelle) created "Dada's Just Desserts," presented by artists, including Roy Lichtenstein, Jenny Holzer, and Cindy Sherman. A series of performances by choreographer Bill T. Jones, Robert LaFosse, the star of New York City Ballet, and artist Lesley Dill's touching AIDS elegy set to the Emily Dickinson poem "The Soul Has Bandaged Moments" were touching, provocative, and entertaining.

Wood was recuperating and unable to attend. However, she made her appearance electronically at midnight, introduced by her friend Tippi Hedren, on a giant video screen.

Her five-minute videotaped recollection of the original ball had the audience entranced. It was wonderful to experience the impact of Wood's infectious humanity on this large and sophisticated crowd, and the way in which everyone, from elderly industrial bankers (who had purchased the expensive balcony seats) to young club kids in their late teens on the dance floor, succumbed to her charm and authenticity. At the end of this short film she received an ovation that all but lifted the roof off Webster Hall.

Wood was followed by Rrose Selavy's Dada Ball Gown Spectacular, which began with the curtain rising on one of William Wegman's dogs modeling Cinderella's ball gown, and was followed by all kinds of extravaganzas: Dale Chilhuly's gown made from two thousand glass grapes, Robert Kushner's gown made from fresh vegetables, Michael Lucero's contribution made from gold phalluses, and the sheer beauty of Phillip Maberry's spectacular entry made with a gold glazed bodice and a skirt, ten feet in diameter, of red cellophane that appeared to be hot and molten as the light played off its surface.

Vogue hailed the night as having "all the makings of a modern social triumph." The *New York Times* warned attendees to "Leave Your Boredom at the Door." *New York Newsday* hailed it as a "Bohemian Rhapsody" that attracted, among others, socialites like Blaine Trump, actresses Marisa Tomei and Uma Thurman, and the cream of the New York art world. CNN ran a five-minute international report on the night for three nights. VH1, CBS, and a half dozen other stations carried the event as well. It was a memorable night, and by the time the stragglers left at 4:00 A.M. we had celebrated Wood's 101st year, her recovery, the (re)emergence of Dada in New York, and even raised money for AIDS organizations.

DENYING GRAVITY

After her illness there was a slowing down in Wood's career. In January of 1995 she wrote, "I will hold my breath for the next two days to see if the kiln is a first-class S.O.B. or whether it will slow down and cooperate with me. I have five pieces ready [for your exhibition in April] and if there is any luck in the stars, seven or eight might be ready shortly."[42]

Despite her medical problems, Wood had six one-woman exhibitions of her pottery and drawings in 1995 and 1996; all included new pieces. She still worked to a rigorous schedule, requiring all correspondence to be answered within forty-eight hours and devoting part of each day to work in the studio—although she grumbled about how small a part of her day this had become.

Wood's work from this period reflected her quieter pace. The glazes cooled slightly from the hot, impetuous pinks of the 1950s and '60s. The forms took a softer, more relaxed, and even more playful line. The craftsmanship was, as always, haphazard though sufficient to be eloquent. Her throwing lines meandered and her forms settled comfortably into slightly asymmetrical shapes. Even at this point in her life, Wood's pottery remained a triumph of what the art historian and her close friend Francis M. Naumann so aptly characterizes as the "Dada state of mind." Seven decades previously Duchamp had told Wood never to obey rules. "Rules are fatal to the progress of art," he warned. By following this advice she enriched and expanded the definition of luster pottery as an art form. What has been achieved is an almost shamanistic act, taking forms that are tied to the cultural rituals of daily use and making magic with fire, color, and light. The works that emerged are not elitist despite their gilded surface opulence. They are works of intimacy and accessibility with a simple, honest beauty that accurately reflects the nature of the sensitive humanist who brought them to life.

The art media were beginning to accept and understand the extraordinariness of Wood's persona and to focus instead on her work, this magical ceramic inheritance that she has left us. In a 1988 *Village Voice* review entitled "Gold from Wood," John Perreault perceptively wrote, "In general artists are pretty dull people, it is their art that makes them interesting. . . . Beatrice Wood has a different problem; she's had such an interesting life that it may be difficult to look at her art without the legend getting in the way. . . . I suspect that as her work becomes better appreciated, her biography will seem less

Receiving kisses. Mark Del Vecchio and Garth Clark visit Beato in Ojai in 1994 after her illness.

and less interesting. A biography is just a series of events . . . whereas artworks can give a voice to whatever is inside."[43]

On March 3, 1997, the day of her 104th birthday, *Beatrice Wood: A Centennial Tribute* opened at the American Craft Museum in New York, Wood's third retrospective exhibition. Curated by Francis M. Naumann, the exhibition provided a broad panorama of Wood's talents. Aside from the figures, which were poorly received, her exhibition received an enthusiastic endorsement from the art critics. Probably the most touching of the accolades came from Robert Kushner's "Letter to Beatrice Wood," published in *Art in America.* He said exactly what Beatrice wanted to hear when he wrote in his opening paragraph, "Beatrice, you have fully seduced me. Not by your beauty and feminine wiles, your demurely raunchy wit and famed naughtiness, your bohemianism, nor your extraordinary sense of personal style. What did it was the sheer, overwhelming beauty of the objects you have created." Though Kushner was not without reservations about some parts of her oeuvre, and he voiced these bluntly, he singled out one of the pieces in the exhibition, *Dinner Service for Eight* (1982–92), as "an uncontested masterpiece of late 20th century art."[44] Wood was ecstatic with the review, loving yet not patronizing, and speaking only of her art at a time when she was having difficulty making any new work.

[23]

DEPARTURE

Beatrice did not die on March 12, 1998, so much as she made a decision to voluntarily and graciously depart. On the Sunday previous she had briefly attended a party for three hundred guests to honor her on the occasion of her 105th birthday. The next day she had dinner with James Cameron, the director of *Titanic,* who had used Beatrice's life (with her permission) to craft an identity for Rose, his one-hundred-year-old survivor in the film. The film begins in a potter's studio that mimics Beatrice's own workshop. She had also just received a check for $275,000 for the film rights to her life, had opened two one-person shows, and her latest retrospective was touring the United States. She had become

Beatrice Wood, the last photo, taken at her 105th birthday party, Ojai.

world famous. She had also amassed a small fortune. Her estate, to the surprise of most of her friends (myself included), was valued at five million dollars. She was, as Michael Kimmelman described her in the *New York Times,* "The 'It' girl of the avant-garde."[45]

All her responsibilities were taken care of and Beatrice was nothing if not dutiful. The retrospective and the potential of a film about her had satisfied her remaining career goals. The time had come to take her leave. On the following day she announced that she did not want to see the mail. Her staff was shocked, as this had always been the high point of her daily routine. Then she announced that she did not want any doctor entering her

home and, less than a day later, quietly, no doubt dreaming of chocolates and young men, possibly visualizing heavenly luster glazes beyond the reach of mere science, she let go and drifted away.

Hours after her passing I was asked by the *Los Angeles Times* to write a lengthy obituary. I had no time for grief or analysis. The words had to flow directly from the heart and be faxed immediately to make the newspaper's impending deadline. It was a perfect request, in a way, for it assisted me in coping with a sense of loss that threatened to overwhelm. The final paragraphs of this piece, with an adjustment or two, in some ways my last letter to Beato, seem to be a fitting ending to this book.

I first met Beatrice when she was a youthful 85 and even then she played the courtesan superbly, flirting with outrageous coquettishness. In part she was satisfying the legend that visitors had come to expect and, after her years on the stage with the French National Repertory Company, Beatrice knew how to deliver on a role. But it was also genuine because Beatrice adored men. One could see her blue eyes twinkle with interest and her back straighten when a handsome man entered the room. On my last visit to Beatrice (she was still only 104) she described a couple coming by to visit with their young son. "I have no idea how old he was," she recalled, "maybe sixteen or seventeen. But he was a little gem of manhood. If I was three months younger, I would have gone for him."

Wood's relationship to men confused feminists for whom she was something of a role model — an independent woman artist who had carved out a career on her own. When they met her they found her ideas antithetical, even infuriating. Once, in response to a question about her career from a woman writer, Beatrice responded, "Oh that, I'd give it all up tomorrow for the chance to dance the tango with a handsome Argentinean." The writer left confused and saddened but had missed the point. Wood's teasing was pure Dada. She had learned games of irony and perversity from the Duchampian master himself. But part of that statement was genuine. It expressed a longing for that one special relationship that over a hundred years of life could neither deliver nor erase.

As a child, Wood grew up believing in an ideal union, firmly convinced that she would find her knight on a white horse. Instead she fell in love seven times but never married any of these men. Her husbands were strays that she took into her life. Later she learned it was wiser to restrict herself to the canine and feline variety. However, there was nothing casual about her affairs. She remained close friends with Duchamp, Roché, and others throughout their lives and was on good terms with most of their wives besides.

We were friends for twenty years and I know why her lovers clung to her friendship even after the passion faded. Beatrice had a way of bringing light and optimism into one's life. Witty, positive, and a fascinating raconteur, she was able to communicate her enthusiasm for life and for the "now." While she may have enjoyed telling stories from her long life, she never lived in the past. She was an extraordinary friend. Almost every momentous moment [in my life] during our friendship is punctuated with a letter from Beatrice, congratulating, encouraging, and commiserating. I never knew where she found the time to write these elegant, warm, poetic notes. Many of the times I did not even know how she had found out about those moments in my life.

She altered my life profoundly. Because of Wood, I am now an art dealer. Wood helped shape and mold the gallery through her patience, enthusiasm, and her example as the most professional and dedicated artist with whom I have worked. She never once missed a deadline for an exhibition. She usually delivered more works than we had requested.

To say that I will miss her is curiously incorrect. There are some people whose passing cannot lessen their daily presence in one's life. In a perverse way, it even heightens their role. Certainly, I mourn that I cannot drop in at her studio and home in Ojai and enjoy her laughter, lively discussions about art, sex, and politics. I will miss the aromatic meals off her glittering plates. I will miss walking after her as she shuffled barefoot to her studio to show me the latest "horrors," as she jokingly referred to her newly fired work in the kiln.

Death alone does not take away a spirit as vital and contagious as that of Beatrice Wood. She lives on in the life of her many friends and one must compliment God for the wisdom of allowing her to stay somewhat longer than the average mortal. Certainly, she used that time wisely and played out a life that shimmered, glittered, sparkled, and seduced every bit as much as the luster pots she made for the last sixty-five years.[46]

The final word, however, belongs to Beatrice. Usually when she was asked about her philosophy and the secret to her long life, she playfully responded with one of her standard ripostes: "art books, chocolates, and young men." Surely these are the ingredients of a certain frisson in her life, but in an interview in 1986 with the *Los Angeles Times,* she explained her philosophy of life differently and with a remarkable economy: "The Japanese have these little [poems]—what do you call them?—yes, haiku. This is mine. The first sentence is, 'Now,' which I firmly believe in. Everything's in the present. I try to run my business, pay my bills, keep my appointments, do it all squarely in the now. The second sentence is, 'Shit,' because nothing really matters. That's *really* profound. The third sentence is, 'I do not know.' That's the whole philosophy."[47]

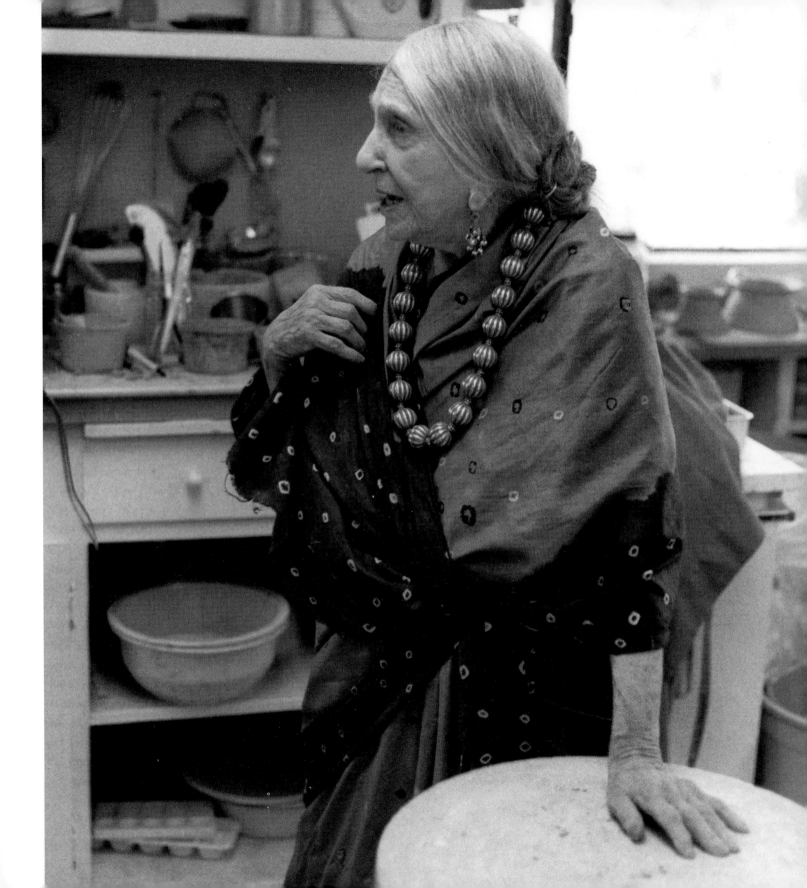

NOTES

1. All unascribed quotes are drawn from my conversations with Beatrice Wood, some noted, some remembered, over more than two decades of friendship.

2. Michael Kimmelman, "A 'Titanic' Figure of the Avant-Garde," *New York Times Magazine,* January 3, 1999, p. 42.

3. Elizabeth Reynolds Hapgood, "All the Cataclysms: A Brief Survey of the Life of Beatrice Wood," *Arts Magazine* 52, no. 7 (March 1978): 107.

4. Beatrice Wood, *I Shock Myself* (San Francisco: Chronicle Books), 1988, p. 4.

5. The book was published in its unfinished state as part of volume four in Jean Clair, *Marcel Duchamp: Catalogue Raisonné* (Paris: Centre d'Art et de Culture Georges Pompidou, 1977).

6. This vivid quotation by Wood is taken from the film *Beatrice Wood: Mama of Dada,* Wild Wolf Productions, 1992.

7. This quote is taken from the first line in the original manuscript for Wood's autiobiography, *I Shock Myself,* which was inadvertently left out of the text when the book was edited prior to publication.

8. Wood, quoted in Helen Dudar, "Beatrice Wood in Her Second Century: Still Going Strong," *Smithsonian,* March 1994, p. 86.

9. Wood, quoted in Susan Morgan, "The Brimming Bowl of Beatrice Wood," *Los Angeles Times,* February 28, 1993, p. 2.

10. Beatrice Wood, "Marcel," in *Marcel Duchamp: Artist of the Century,* edited by Rudolf E. Kuenzli and Francis M. Naumann (Cambridge: MIT Press, 1990), p. 12.

11. Quoted in Roger L. Conover, "Mina Loy's Collussus, Arthur Cravan Undressed," in Rudolf E. Kuenzli, *New York Dada* (New York: Willis Locker and Owen, 1986), p. 106.

12. Wood in an interview with Don Stanley, "She Remembers Dada," *Los Angeles Times Magazine,* October 5, 1986, p. 20.

13. Kimmelman, "A 'Titanic' Figure of the Avant-Garde," p. 42.

14. Wood, quoted in Francis M. Naumann, *New York Dada 1915–1923* (New York: Abrams), 1994, p. 43.

15. Conover, "Mina Loy's Collussus," p. 106.

16. Henri-Pierre Roché, *Victor* (Paris: Centre d'Art et de Culture Georges Pompidou, 1977), p. 55.

17. See Calvin Tomkins, *Duchamp: A Biography* (New York: Henry Holt, 1996), pp. 188–89.

18. Hapgood, "All the Cataclysms," p. 109.

19. At first the Arensbergs lived in a small bungalow on the grounds of Frank Lloyd Wright's Hollyhock House, later moving to a large house in Echo Park. For a couple of modernists, the choice of architecture—staid Georgian revival mansion—was suprising. The house gave no outward hint of the radical art that hung inside on its walls. Wood enjoyed the contrast. First-time visitors would often be shocked by the contrast when they entered the Arensbergs' home. "It was like being hit in the face with a brick," says Wood. Through the Arensbergs she met another collector, Galka Scheyer, who introduced Wood to German expressionism, which Wood came to appreciate under Scheyer's aggressive tutelage. The Arensbergs, Scheyer, and Helen Freeman became Wood's California family, seeing her through many crises and providing encouragement and support when she began her ceramic career.

20. The first exhibition took place at the Los Angeles County Museum of Art and was organized by Reginald Poland. Glen Lukens hailed this event as meaning that "the Pacific Coast ceramic child is able to walk alone." Quoted in Roger Hollenbeck, "Review," *The Bulletin of the American Ceramic Society,* April 1938, p. 194. See also "California Ceramics," *Art Digest,* 1938, p. 16.

21. Wood, "And That Is How I Became a Potter," *Ceramics: Art and Perception* 18 (1994): 33.

22. Wood, "Craftsmen Experience," *Craft Horizons,* August 1944, p. 20.

23. Anaïs Nin, "Beatrice Wood," *Artforum,* January 1965, p. 25.

24. Wood, quoted in Francis M. Naumann, *Intimate Appeal: The Figurative Art of Beatrice Wood* (Oakland, Calif.: Oakland Museum, 1990), p. 39.

25. Ibid.

26. Ibid., p. 36.

27. Wood, *I Shock Myself*, p. 37.

28. Jody Clowes, "Foot, Belly, Shoulder, Lip," in *The Nude in Clay* (Chicago: Perimeter Gallery, 1995), p. 10. The comment was in response to a work in the exhibition entitled *OH, LA LA* (1994).

29. Daisetz T. Suzuki, *Zen and Japanese Culture* (New York: Pantheon Books, 1959), p. 23.

30. Roger Fry, *Catalogue of the Omega Workshop,* London, c. 1914, unpaginated.

31. Letter from Wood to the author, October 23, 1989.

32. Wood, "And That Is How I Became a Potter," p. 34.

33. Letter from Wood to the author, October 30, 1988.

34. Wood, quoted in John Perreault, "Gold from Wood," *Village Voice,* March 1, 1988.

35. Wood in "New Pots for Old," unpublished manuscript, p. 2. The document is dated 1937 but this seems to be an error as it contains a discussion about the Natzlers, whom she did not know about until 1940. The article is more likely to have been written in 1947.

36. Ibid.

37. John Perreault, "Gold from Wood," *Village Voice,* March 1, 1998.

38. Letter from Wood to the author, December 27, 1992.

39. Roberta Smith, "Beatrice Wood," *New York Times,* April 2, 1993, p. C29.

40. Brooks Adams, "Beatrice Wood at Garth Clark," *Art in America,* September 1993, p. 117.

41. Letter from Wood to the author, November 22, 1993.

42. Letter from Wood to the author, January 27, 1995.

43. Perreault, "Gold from Wood."

44. Robert Kushner, "Letter to Beatrice Wood," *Art in America,* January 1998.

45. Michael Kimmelman, "Heart of Modern Art," *New York Times,* December 27, 1998.

46. Garth Clark, " A True Romantic and Pragmatist," *Los Angeles Times,* March 16, 1998.

47. Wood, quoted in Don Stanley, "She Remembers Dada," *Los Angeles Times Magazine,* October 15, 1986, p. 21.

AWARDS

1994 Governor's Award for the Arts, State of California

1993 Recognition as "A Role Model" by Woman in Film

1992 Gold Medal for Highest Achievement in Craftsmanship,
 American Craft Council

1988 Distinguished Service Award, Arizona State University

1987 Fellow of American Craft Council Women's Art Caucus;
 National Award; NCECA Award

1986 Women's Building Award

1984 Living Treasure of California

1983 Symposium Award of the Institute for Ceramic History

1961 Goodwill Ambassador from the United States to India

SELECTED PUBLIC COLLECTIONS

American Craft Museum, New York

Brooklyn Museum of Art, Brooklyn, New York

Centre d'Art et de Culture Georges Pompidou, Paris

Charles A. Wustum Museum of Fine Arts, Racine, Wisconsin

Cooper Hewitt Museum, New York

Detroit Institute for the Arts, Detroit, Michigan

Everson Museum of Art, Syracuse, New York

Los Angeles County Museum of Art, Los Angeles, California

Metropolitan Museum of Art, New York

Mint Museum of Craft + Design, Charlotte, North Carolina

Museum of Art, Carnegie Institute, Pittsburgh, Pennsylvania

Museum of Fine Arts, Boston, Massachusetts

Museum of Modern Art, New York

Nelson Atkins Museum of Art, Kansas City, Missouri

Newark Museum of Art, Newark, New Jersey

Oakland Museum, Oakland, California

Philadelphia Museum of Art, Philadelphia, Pennsylvania

Renwick Gallery, Smithsonian American Art Museum, Washington, D.C.

Staatliche Museen Preussischer Kulturbesitz, Berlin

Victoria and Albert Museum, London

SELECTED BIBLIOGRAPHY

Writings by Beatrice Wood

"Dream of a Picture Hanger," *The Blind Man,* April 10, 1917.

"Why I Came to Independence," *The Blind Man,* April 10, 1917.

"Craftsmen Experience," *Craft Horizons,* August 1944.

"The Work of the Art Potter," *Ceramic Age,* October 1948.

"I Shock Myself: Excerpts from the Autobiography of Beatrice Wood," *Arts Magazine,* May 1977.

"Foreword," in Alice Goldfarb, *Marcel Duchamp: Eros, c'est la vie: A Biography.* Troy, N.Y.: Whitson, 1981.

The Angel Who Wore Black Tights. Ojai, Calif.: Rogue Press, 1982.

I Shock Myself. Ojai, Calif.: Dillingham Press, 1985.

Pinching Spaniards. Ojai, Calif.: Topa Topa, 1988.

Touching Certain Things. Los Angeles, Calif.: MGM Press, 1992.

33rd Wife of a Maharajah: A Love Affair in India. Bombay, India: Allied Publishers, 1992.

Playing Chess with the Heart: Beatrice Wood at 100, Photography by Marlene Wallace. San Francisco, Calif.: Chronicle Books, 1993.

Madame Lola's Pleasure Palace (as Countess Lola Screwinsky). Ojai, Calif.: Beatrice Wood, 1994.

Kissed Again: Part of the Bargain (as Countess Lola Screwinsky). Ojai, Calif.: Pleasure Palace Books, 1995.

Books and Catalogs

Camusso, Lorenzo, and Sandro Bortone. *Ceramics of the World from 4000 B.C. to the Present.* New York: Abrams, 1991.

Clark, Garth. *A Century of Ceramics in the United States, 1878–1978.* New York: E.P. Dutton, 1979.

——— . *American Potters: The Work of Twenty Modern Masters.* New York: Watson Guptill Publications, 1981.

——— . *Ceramic Echoes: Historical References in Contemporary Ceramics.* Kansas City, Mo.: The Contemporary Art Society, 1983.

——— . *American Ceramics, 1876 to the Present.* New York: Abbeville Press, 1988.

——— . *The Eccentric Teapot.* New York: Abbeville Press, 1989.

——— . *The Book of Cups.* New York: Abbeville Press, 1990.

——— . *The Artful Teapot.* London: Thames and Hudson, 2001.

——— . *Shards: Selected Writings on Ceramic Art by Garth Clark.* New York: CAF Press, 2002.

Clark, Garth, and Suzanne Foley. *A Fire for Ceramics: Contemporary Art from the Daniel Jacobs and Derek Mason Collection.* Richmond, Va: Hand Workshop Art Center, 1998.

Clark, Garth, and Francis M. Naumann. *Beatrice Wood: Retrospective.* Fullerton: Art Gallery, California State University, 1983.

Clark, Garth, and Oliver Watson. *American Potters Today.* London: Victoria and Albert Museum, 1986.

Frankel, Robert H. *Beatrice Wood: A Retrospective.* Phoenix, Ariz.: Phoenix Art Museum, 1973.

Hickok, Gloria Vandok, ed. *The Helicon Nine Reader: A Celebration of Women in the Arts, The Best of Ten Years.* Kansas City, Mo.: Helicon Nine Editions, 1990.

Hooker, Alan. *California Herb Cookery from the Ranch House Restaurant.* Illustrated by Beatrice Wood. Ojai, Calif.: Edwin House Publishing, 1996.

Johnston, Phillip M. *Kansas City Collects Contemporary Ceramics.* Kansas City, Mo: Nelson Atkins Museum of Art, 1989.

Lauria, Jo. *Color and Fire: Defining Moments in Studio Ceramics, 1950–2000.* New York: Rizzoli International Publications, 2000.

Levin, Elaine. *1607 to the Present: The History of American Ceramics from Pipkins and Bean Pots to Contemporary Forms.* New York: Abrams, 1988.

Lynn, Martha Drexler. *Clay Today: Contemporary Ceramists and Their Work.* Los Angeles: Los Angeles County Museum of Art, 1990.

Manhart, Marcia and Tom Manhart, eds. *The Eloquent Object.* Tulsa, Okla.: Philbrook Museum of Art, 1987.

Munsterberg, Hugo, and Marjorie Munsterberg. *World Ceramics: From Prehistoric to Modern Times.* New York: Penguin Studio Books, 1998.

Naumann, Francis M. "Beatrice Wood and the Dada State of Mind," *Beatrice Wood and Friends: From Dada to Deco.* New York: Rosa Esman Gallery, 1978.

———, ed. *Beatrice Wood: A Centennial Tribute.* New York: American Craft Museum, 1997.

———. *Intimate Appeal: The Figurative Art of Beatrice Wood.* Oakland, Calif.: Oakland Museum, 1990.

———. *New York Dada 1915–1923.* New York: Abrams, 1994.

———. *Making Mischief: Dada Invades New York.* New York: Whitney Museum of American Art, 1996.

Nordness, Lee. *Objects USA.* New York: Viking Press, 1970.

Pepich, Bruce, and Judy Clowes. *The Nude in Clay.* Chicago: Perimeter Gallery, 1995.

Perry, Barbara, ed. *American Ceramics: The Collection of Everson Museum of Art.* New York: Rizzoli, 1989.

Roché, Henri-Pierre. "Victor," in Vol. 4, Jean Clair. *Marcel Duchamp: Catalogue Raisonné.* Paris: Centre d'Art et de Culture Georges Pompidou, 1977.

Steinbaum, Bernice. *Elders of the Tribe.* New York: Bernice Steinbaum Gallery, 1986.

Tomkins, Calvin. *Duchamp: A Biography.* New York: Henry Holt, 1996.

Vincentelli, Moira. *Women in Ceramics: Gendered Vessels.* Manchester, England: Manchester University Press, 2000.

Periodicals and Reviews

Armitage, Merle. "Beatrice Wood: Artist in Clay," *California Arts and Architecture,* May 1940.

"Beatrice Wood's Ceramics," *Arts and Architecture* 64 (1947).

Bryan, Robert. "The Ceramics of Beatrice Wood," *Craft Horizons,* March 1970, pp. 28–33.

"Ceramics by B. Wood," *Arts and Architecture* 63 (January 1946).

Clark, Garth. "Beatrice Wood Luster: The Art of Ceramic Light," *Helicon Nine,* August 1983.

———. "Beatrice Wood," *American Craft* 43, no. 4 (August/September 1983).

———. "The Art of Ceramic Light: Beatrice Wood," *Ceramic Arts* 1, no. 1 (1983).

———. "Gilded Vessels: The Life and Art of Beatrice Wood," *Ceramics: Art and Perception* 27 (1997).

Freudenheim, Betty. "Lusterware Shown by California Potter," *New York Times,* October 3, 1985.

Gleuck, Grace. "Dada to Pots of Gold: At 104, the View Back Is a Long One," *New York Times,* March 7, 1997.

Hapgood, E. R. "All the Cataclysms: A Brief Survey of the Life of Beatrice Wood," *Arts Magazine,* March 1978.

Hare, Denise. "The Lustrous Life of Beatrice Wood," *Craft Horizons,* June 1978.

Kimmelman, Michael. "A 'Titanic' Figure of the Avant-Garde," *New York Times Magazine,* January 3, 1999.

Knight, Christopher. "Portrait of a Bohemian Artist: Beatrice Wood's Stylish Devices," *Los Angeles Herald Examiner,* February 23, 1983.

Kraft, Barbara. "Guest Speaker: Beatrice Wood," *Architectural Digest,* May 1984.

Morgan, Susan. "The Brimming Bowl of Beatrice Wood," *Los Angeles Times,* February 28, 1993.

Naumann, Francis M. "Drawings of Beatrice Wood," *Arts Magazine,* March 1983.

———. "Walter Conrad Arensberg: Poet, Patron, and Participant in the New York Avant-Garde, 1915–20." *Philadelphia Museum of Art Bulletin,* no. 328 (Spring 1980).

———. "The Big Show, The First Exhibition of the Society of Independent Artists," *Artforum,* February 1979, pp. 34–39.

———. "Introduction" and "Notes" to "I Shock Myself: Excerpts from the Autobiography of Beatrice Wood, by Beatrice Wood," *Arts Magazine,* May 1977, pp. 134–39.

Nin, Anaïs. "Beatrice Wood," *Artforum,* January 1965.

Perreault, John. "Gold from Wood," *Village Voice,* March 1, 1988.

Spiegel, Janet,. "A Dinner with Mama to the Dadas," *Los Angeles Times,* September 25, 1983.

Stanley, Don. "She Remembers Dada," *Los Angeles Times Magazine,* October 5, 1986.

———. "Beatrice Would," *Connoisseur,* November 1988, p. 58.

Films

Special People: Beatrice Wood (1990). Thirty-minute documentary from Pro Video News Service, written, produced, and directed by Joel Arks; gold medal winner for best biography in the thirtieth annual International Film and TV Festival of New York.

Beatrice Wood: Mama of Dada (1993). Fifty-five-minute documentary produced by Wild Wolf Productions, Inc.

INDEX

PHOTOGRAPHY CREDITS

COLLECTOR CREDITS